Georgia 24/7 is the sequel to *The New York Times* bestseller *America 24/7* shot by tens of thousands of digital photographers across America over the course of a single week. We would like to thank the following sponsors, the wonderful people of Georgia, and the talented photojournalists who made this book possible.

JEKYLL ISLAND
Built in 1886, Jekyll Wharf Marina was the yacht anchorage for the Rockefellers and Vanderbilts when they escaped to their winter colony on Jekyll Island.
Photo by Flip Chalfant

LONDON, NEW YORK, MUNICH, MELBOURNE, and DELHI

Created by Rick Smolan and David Elliot Cohen

24/7 Media, LLC
PO Box 1189
Sausalito, CA 94966-1189
www.america24-7.com

First Edition, 2004
04 05 06 07 08 10 9 8 7 6 5 4 3 2 1

Published in the United States by
DK Publishing, Inc.
375 Hudson Street
New York, NY 10014

DK Publishing, Inc. offers special discounts for bulk purchases for sales promo-
tions or premiums. Specific, large-quantity needs can be met with special edi-
tions, personalized covers, excerpts of existing guides, and corporate imprints.
For more information, contact:

Special Markets Department
DK Publishing, Inc.
375 Hudson Street
New York, NY 10014
Fax: 212-689-5254

Cataloging-in-Publication data is available
from the Library of Congress
ISBN 0-7566-0050-2

Printed in the UK by Butler & Tanner Limited

First printing, October 2004

ATLANTA

First called "Terminus" because it was at the
end of the Western & Atlantic railroad line,
then "Marthasville" after an early governor's
daughter, Atlanta became Georgia's capital
by popular referendum in 1877. Today, the
city's population is just 420,000, but its
metro area counts more than 3 million souls.
Office towers designed by Philip Johnson, I.M.
Pei, and Marcel Breuer shape the city's profile.
Photo by Steven Schaefer

GEORGIA 24/7

24 Hours. 7 Days.
Extraordinary Images of
One Week in Georgia.

Created by Rick Smolan and David Elliot Cohen

DK Publishing

About the America 24/7 Project

A hundred years hence, historians may pose questions such as: What was America like at the beginning of the third millennium? How did life change after 9/11 and the ensuing war on terrorism? How was America affected by its corporate scandals and the high-tech boom and bust? Could Americans still express themselves freely?

To address these questions, we created America 24/7, the largest collaborative photography event in history. We invited Americans to tell their stories with digital pictures. We asked them to shoot a visual memoir of their lives, families, and communities.

During one week in May 2003, more than 25,000 professionals and amateurs shot more than a million pictures. These images, sent to us via the Internet, compose a panoramic yet highly intimate view of Americans in celebration and sadness; in action and contemplation; at work, home, and school. The best of these photographs, more than 6,000, are collected in 51 volumes that make up the America 24/7 series: the landmark national volume America 24/7, published to critical acclaim in 2003, and the 50 state books published in 2004.

Our decision to make America 24/7 an all-digital project was prompted by the fact that in 2003 digital camera sales overtook film camera sales. This techno- logical evolution allowed us to extend the project to a huge pool of photographers. We were thrilled by the response to our challenge and moved by the insight offered into American life. Sometimes, the amateurs outshot the pros—even the Pulitzer Prize winners.

The exuberant democracy of images visible throughout these books is a revela- tion. The message that emerges is that now, more than ever, America is a supersized idea. A dreamspace, where individuals and families from around the world are free to govern themselves, worship, read, and speak as they wish. Within its wide margins, the polyglot American nation manages to encompass an inexplicably complex yet work- able whole. The pictures in this book are dedicated to that idea.

—Rick Smolan and David Elliot Cohen

American nightlight: More than a quarter of a billion people trace a nation with incandescence in this composite satellite photograph.
Photo by Craig Mayhew & Robert Simmon, NASA Goddard Flight Center/Visions of Tomorrow

Sweet Georgia

By Bo Emerson

Take a deep Georgia breath and imbibe 12 body-building vitamins and seven essential amino acids. Pumped full of jasmine, gardenia, magnolia, and mimosa, the atmosphere is nutritional; on summer evenings, you can walk out into the Krispy-Kreme-sweet air and lean up against it.

Yes, there is something in the air in this overly blessed, Deep South nation, a place once crushed under Sherman's heel and now the glittering buckle of the Sun Belt. In 1732 James Oglethorpe won a charter from King George II and offered Georgia to the world as a refuge for the "worthy poor." Debtors, the shady, and the intrepid—they could smell it.

Now Georgia booms. The state's mild climate, its right-to-work laws, cheap labor, and pro-business government keep the economic pot simmering even through downturns. Several counties in metro Atlanta, unofficial capitol of the New South, rank among the fastest growing in the country. The shock waves from the money bomb still roll north and south from the Big Peach, knocking down trees and leaving subdivisions and cul-de-sacs in their wake.

Of course, not all the living is easy. Hispanic immigrants labor in the poultry and construction industries without health care or job security. Georgia is high in child poverty and infant mortality. Tensions between rural and urban, black and white, continue to roil the air.

Those tensions surfaced during the recent fight over the state flag and its prominent Confederate battle emblem. A compromise flag was chosen, but before that happened, Georgia's first Republican governor in 130 years rode white

OKEFENOKEE NATIONAL WILDLIFE REFUGE
An American alligator swims through the tannin-rich waters of the Okefenokee

resentment into office and revealed that the Civil War ain't quite history yet.

It's no accident that Ray Charles, singer of our unmatched state song, "Georgia On My Mind," left for Seattle as a teenager and put 3,000 miles between him and his South Georgia hometown.

Who can blame him? For a black man in the 1940s, Georgia wasn't as sweet and clear as moonlight through the pines. On the other hand, for a black man in the 21st century, Atlanta, Georgia, is home to the wealthiest, best educated, and most politically influential African Americans anywhere. Maybe that has to do with the fact that Georgia claims as a native son America's own Gandhi, Dr. Martin Luther King, Jr.

A materialist, striving state, glorying in the treasures of the world, Georgia plumbs deep into faith, where God lives in snake-handling primitive chapels and corporate megachurches. The faithful spirit of Georgia lives in just as many locales: in a paradise called Tybee Island, equal parts pirate, redneck, lunch-bucket bohemian and shabby gentry. Local character Joe Inglesby calls the island "a drinking village with a fishing problem." The spirit is in a velvet Elvis night—high up in the Appalachians, where the spilled milk of the galaxy lights the sky and civilization is just a glow to the south.

The land stretches wide and accommodates, welcoming transplants from Ohio and New Jersey and from farther afield. For these folks, and for many others, Georgia is still the promised land, a frontier as green and raw as it was in 1732.

BO EMERSON, *a fifth generation Georgian, is a long-time feature writer with* The Atlanta Journal-Constitution.

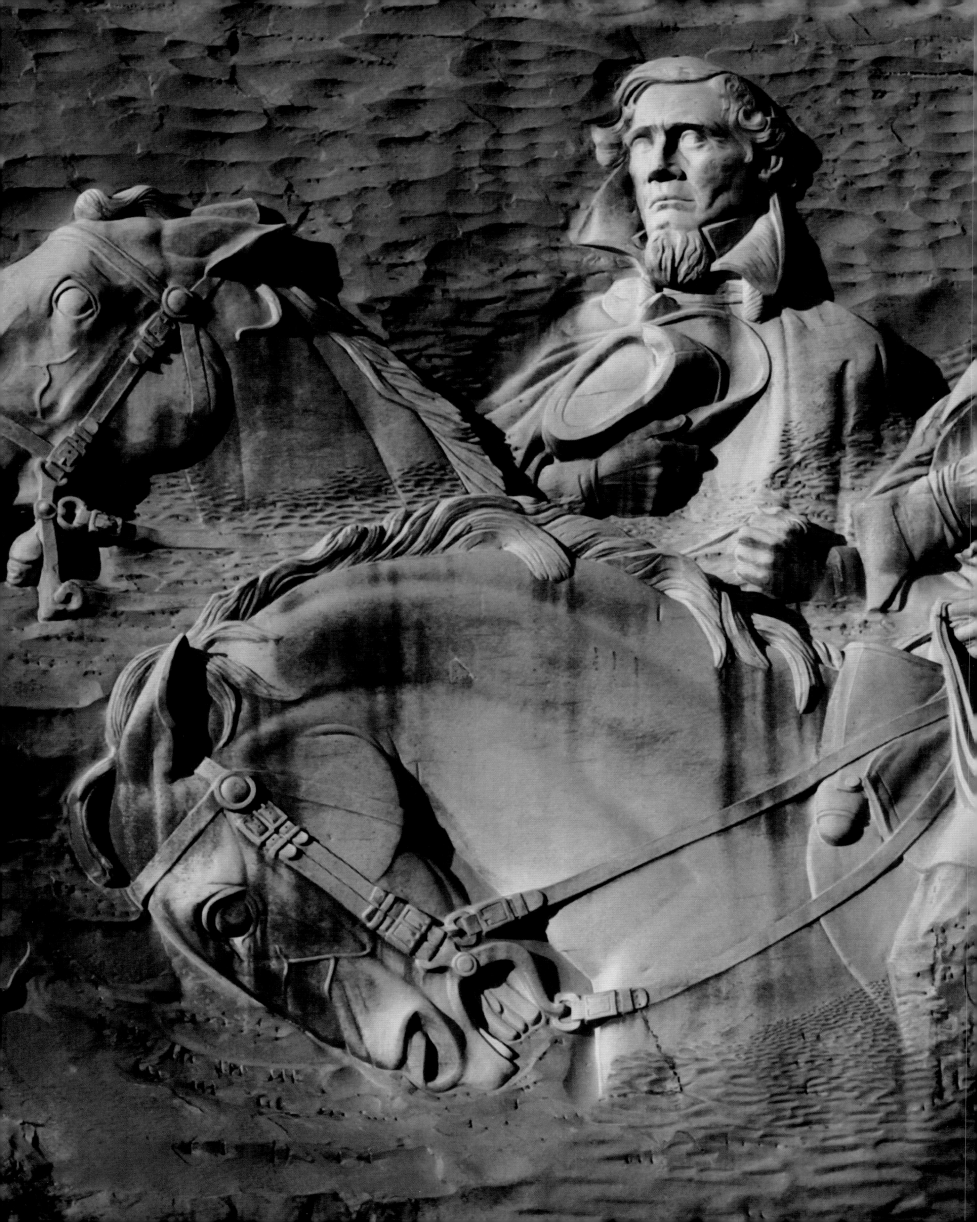

STONE MOUNTAIN
Stone Mountain Park, located 16 miles east of Atlanta, features the world's largest relief sculpture. Chiseled into the side of Stone Mountain, the 3-acre Confederate Memorial Carving depicts Civil War heroes Jefferson Davis, Robert E. Lee, and Thomas "Stonewall" Jackson. Sculptor Gutzon Borglum, of Mount Rushmore fame, started the project in 1923. It was completed by Walker Hancock in 1972.
Photo by Phillip G. Harbin, Jr.

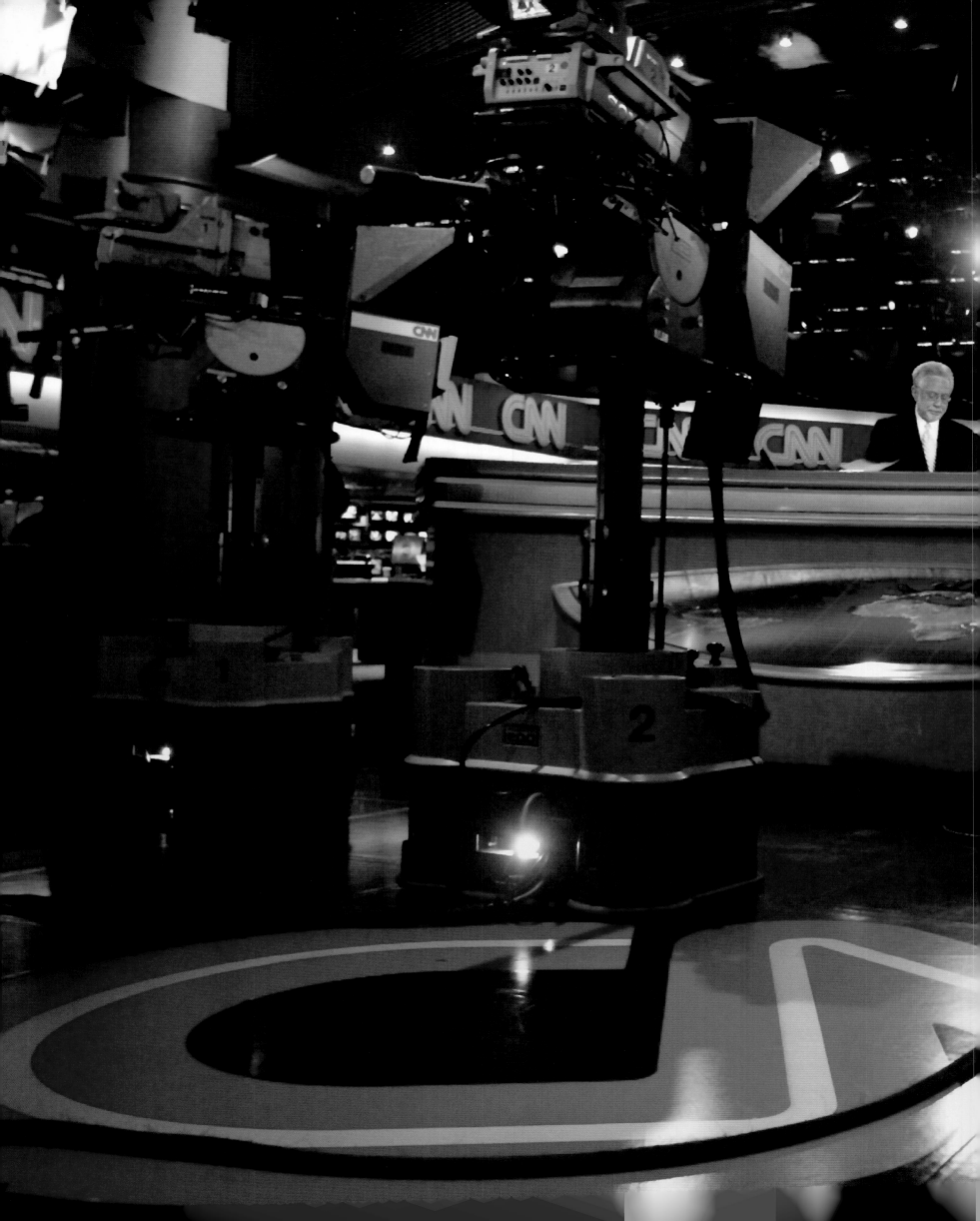

ATLANTA
About to go on-air in the CNN main studio, the *Wolf Blitzer Reports* news hour focuses on the day's top stories: an attack on a western housing complex in Saudi Arabia and a Texas mom accused of killing her kids. Up to 200 people work in the newsroom during a breaking news event.

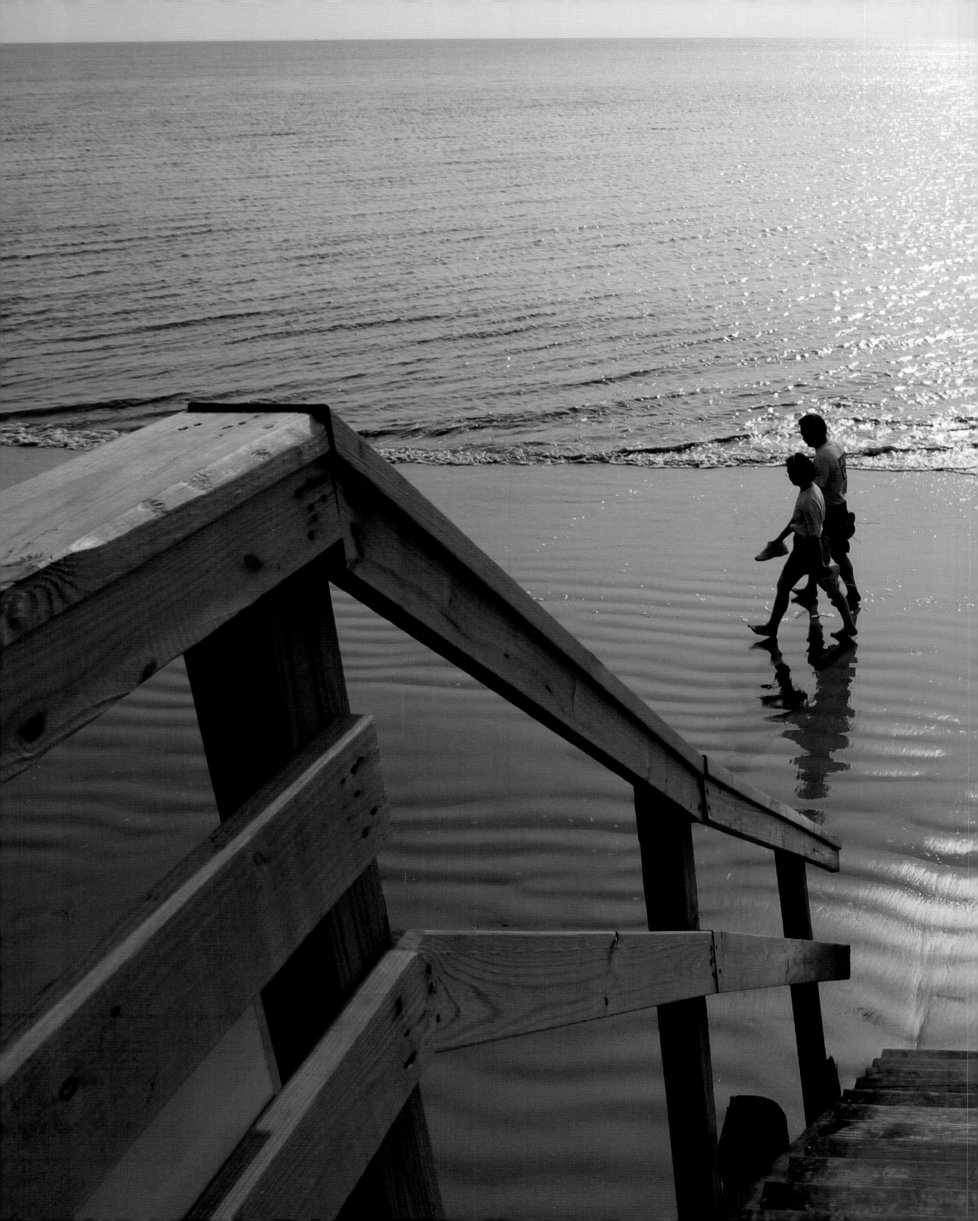

JEKYLL ISLAND
As gentle as it gets: The Atlantic Ocean laps at Jekyll Island's beach. The 5,000-acre barrier island, now thick with golf courses and hotels, was once the exclusive winter escape for a handful of America's rich industrialists.
Photo by Flip Chalfant

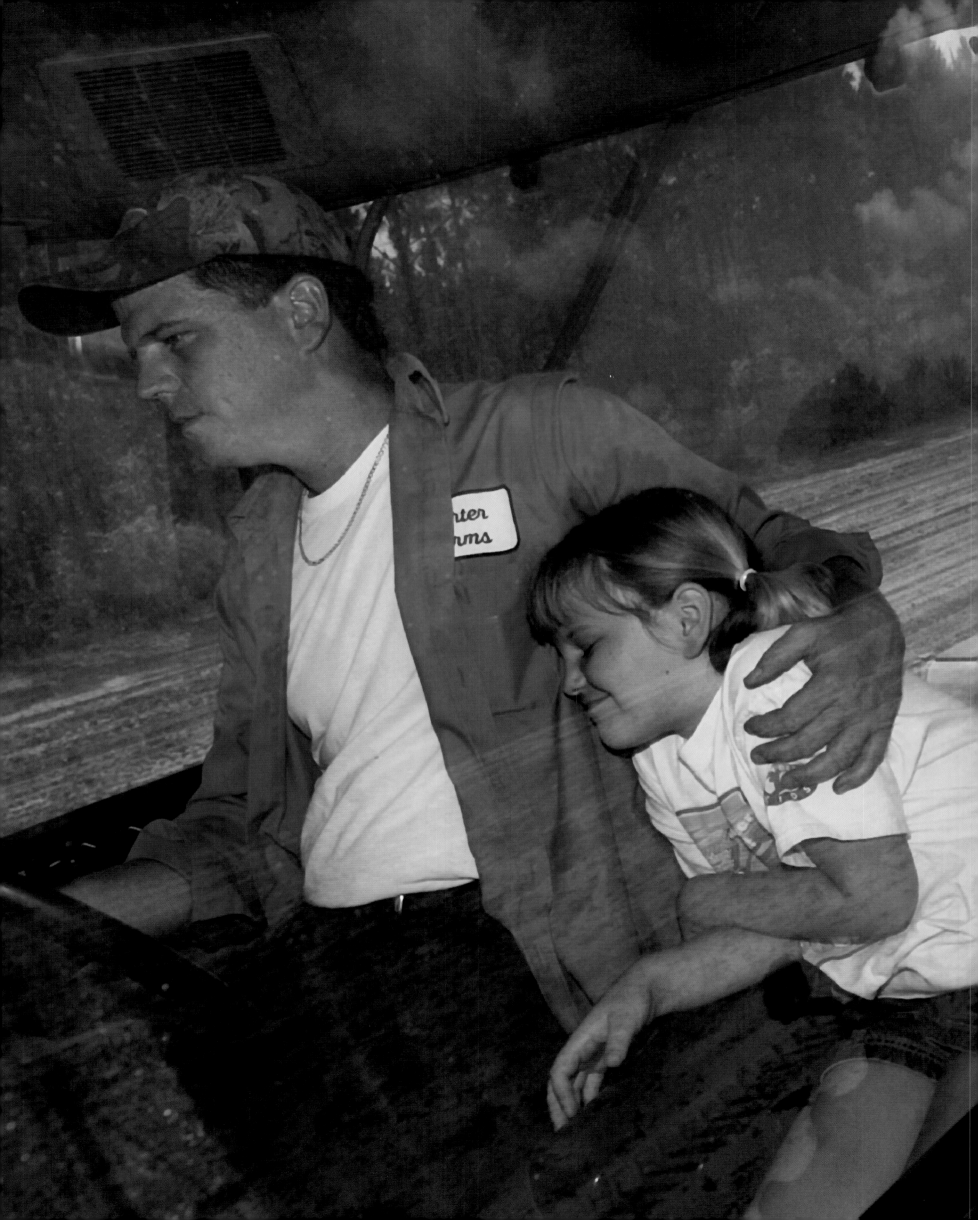

ANDERSON CITY
Since Courtney was a baby, she's been riding shotgun with dad on his tractor. The Carter team lays down cotton seed on a field on their 2,000-acre farm.
Photo by Rich Addicks,
The Atlanta Journal-Constitution

AUGUSTA
Concert goers give up a hip-hop hooray during the annual Mayfest concert held in May Park. Atlanta rappers Lil' John & The Eastside Boyz topped the bill, but local favorite Klutch got the 30,000-strong crowd bumping with his homegrown rhymes.
Photo by Rob Carr

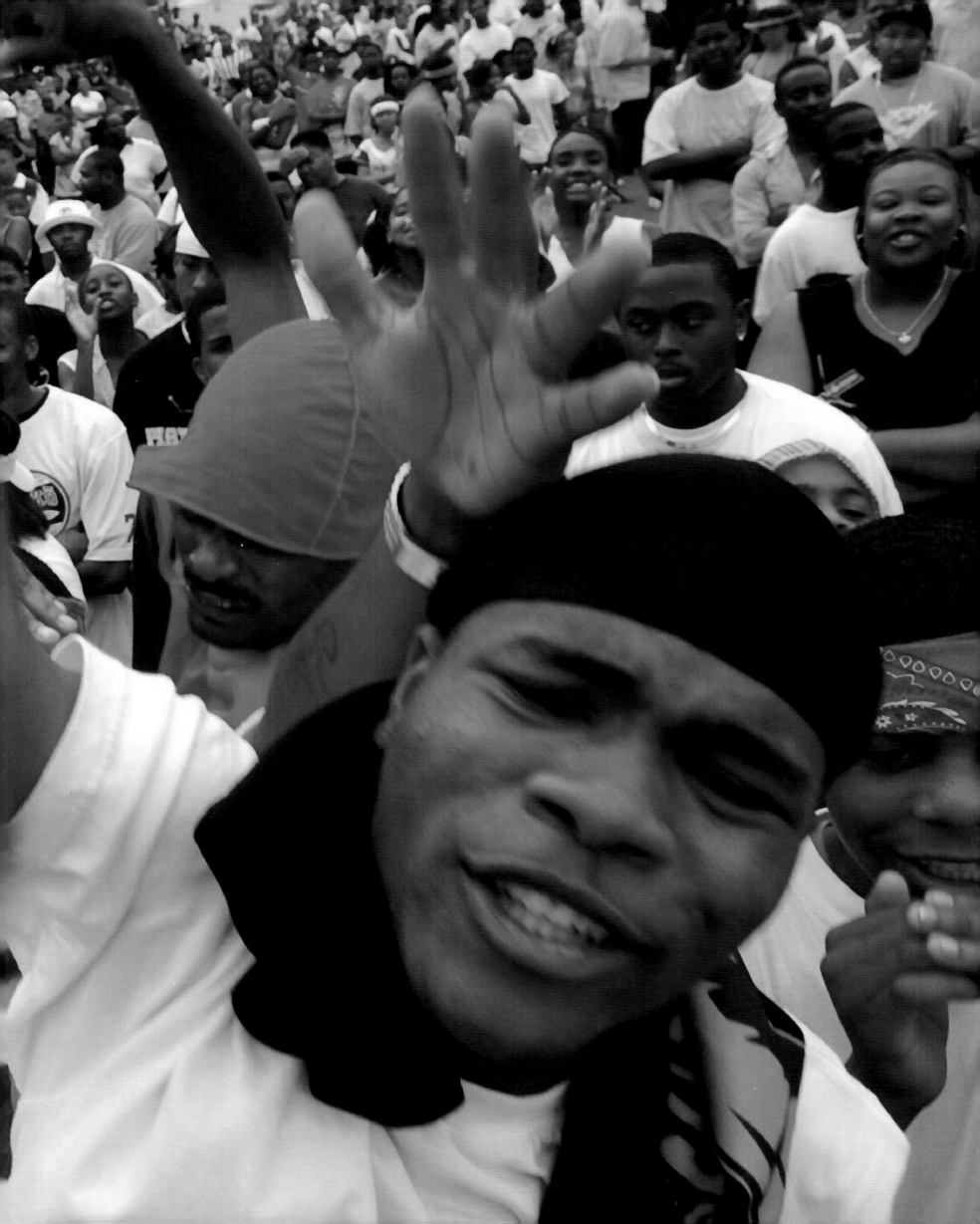

Hearth & Home

It's another hectic morning in the Webster house-
hold. Donna usually takes care of 11-month-old
Luna, while husband James manages Maya, 4.
Luckily, day care, preschool, and work are nearby.
Donna is an engineer, James is a scientist, and
both are employed by the EPA in downtown
Atlanta.
Photo by Tova R. Baruch

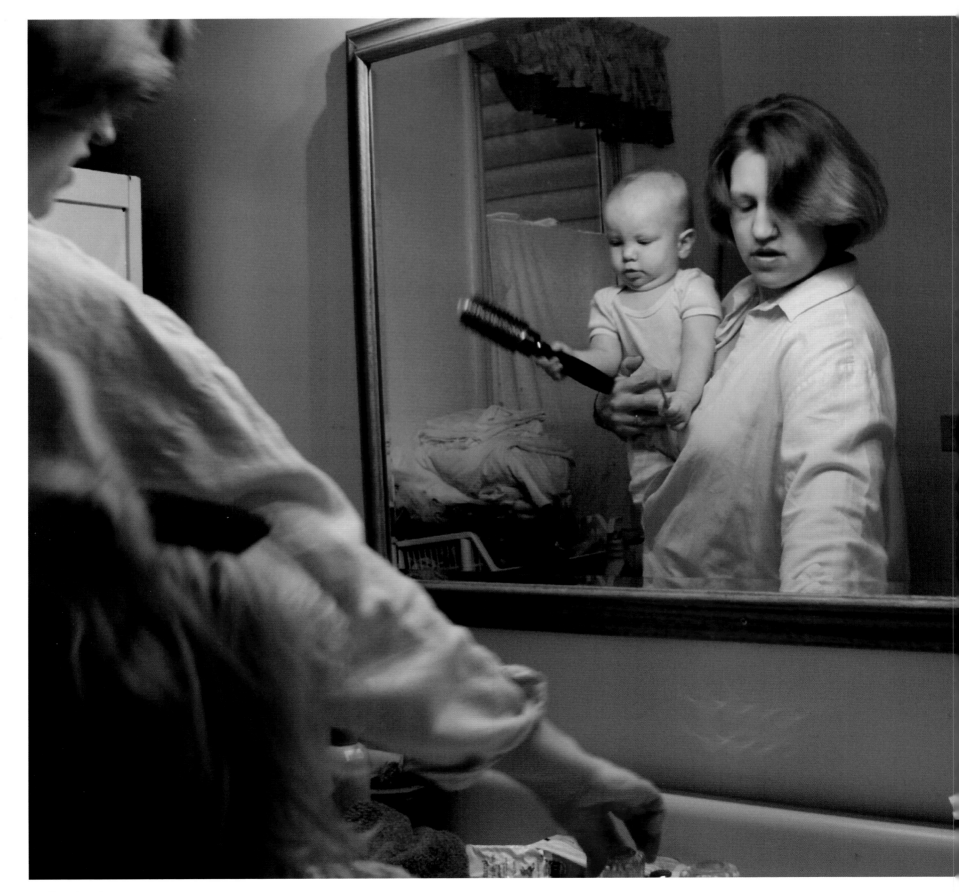

OKEFENOKEE NATIONAL WILDLIFE REFUGE
Left high and dry by the creation of the wildlife refuge, the old Chesser family homestead on Chesser Island got its second wind as a model of swamp life. Matriarch Iva Chesser, who left the island with her family in 1958, supervised the restoration.
Photos by Rachel LaCour Niesen

OKEFENOKEE NATIONAL WILDLIFE REFUGE

Bill Chesser and his six brothers and sisters were born in this room. The family was forced to move from their island homestead in 1958 when the Okefenokee swamp around them became a national wildlife refuge. "My dad didn't want to move," says Chesser, whose great-grandparents settled on the island in the 1850s. "We were the last to leave the island."

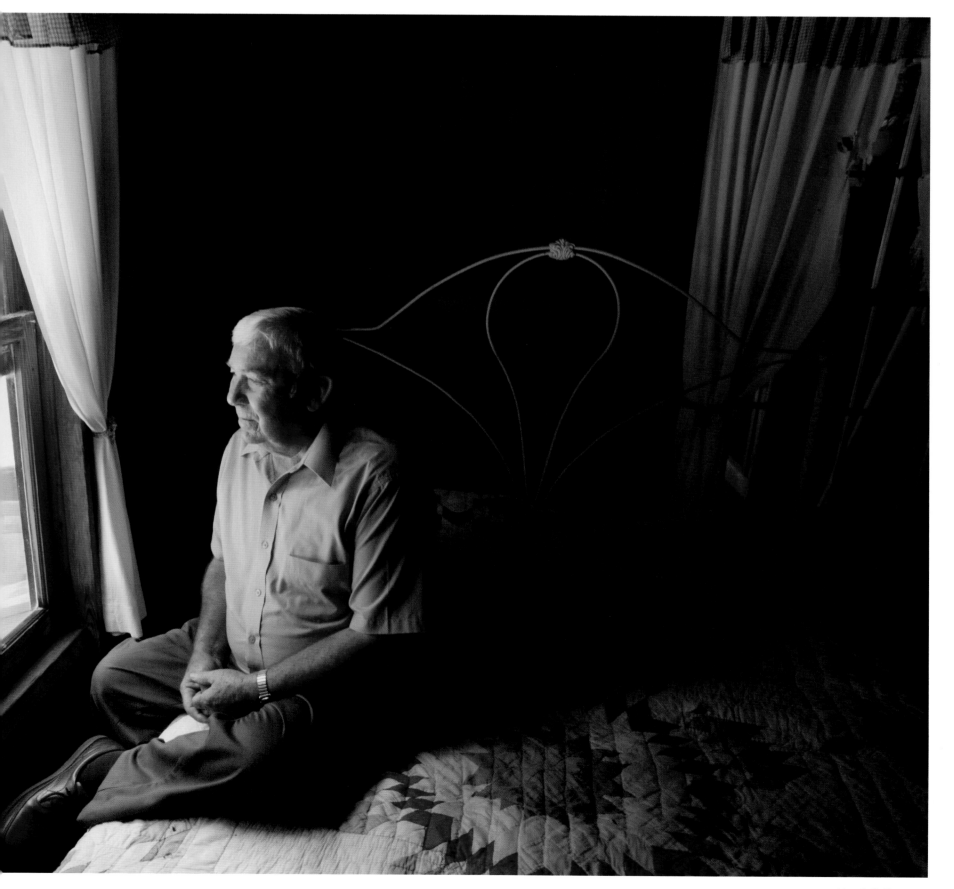

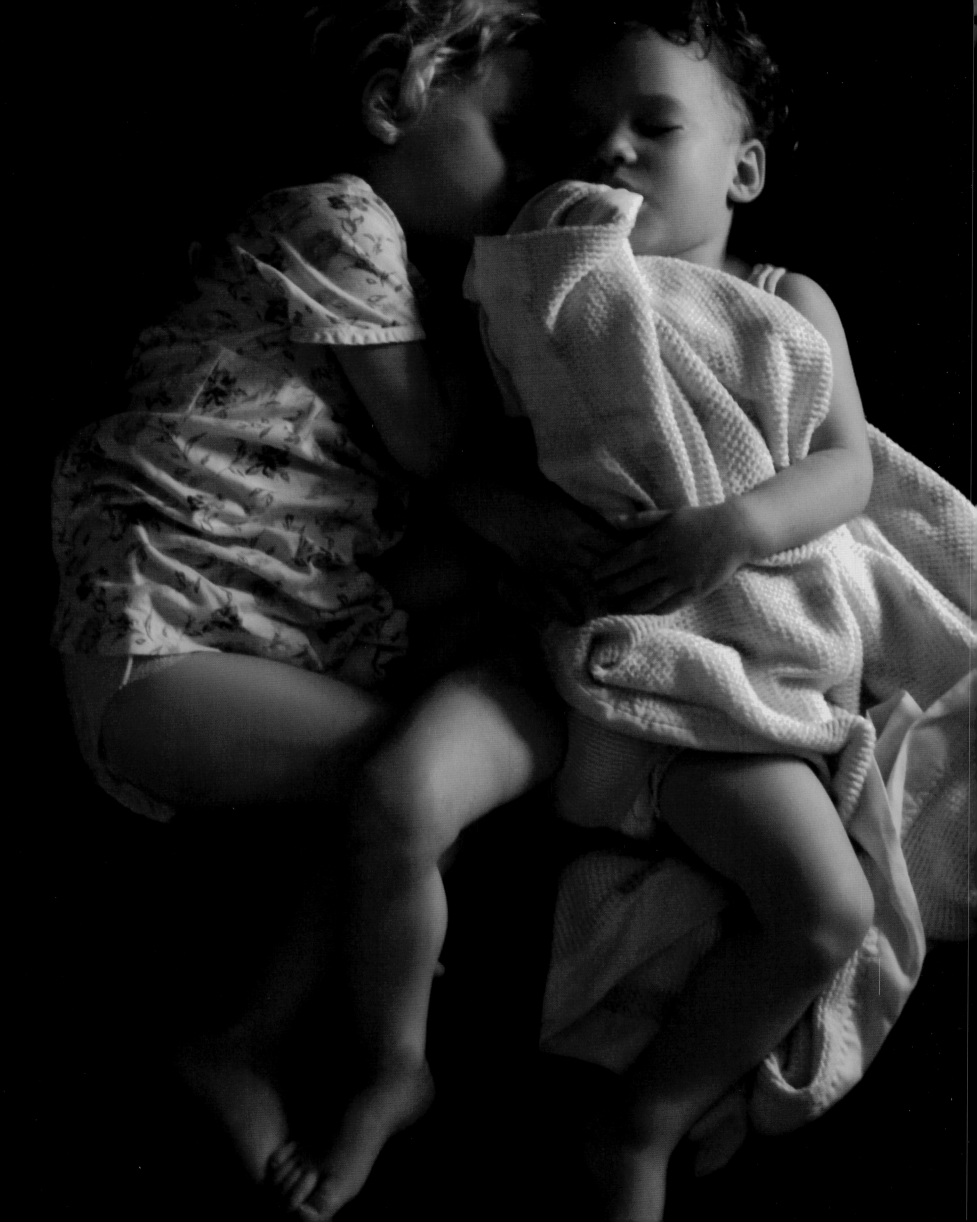

CRESCENT

When Cali and Lili Chalfant of Atlanta go with mom and dad to their cabin in Crescent, the sleeping arrangements are casual, and they often get to sleep with their parents in the big bed. "When they fall asleep, it's like a lull in a storm," dad says.

Photo by Flip Chalfant

ATLANTA

Adrianne Gray took a year's leave of absence from her job as a Delta flight attendant so she could be a full-time mom. "I love every moment of it, " says Gray on a Friday morning, still under the covers with 5-month-old Sylvia.

Photo by Ben Gray

ATLANTA

David Noel plays in a band until the wee hours of the morning. As luck would have it, his 1-year-old son Alexander is a morning person, who's cool with dad catching a few extra winks.

Photo by Laura Noel

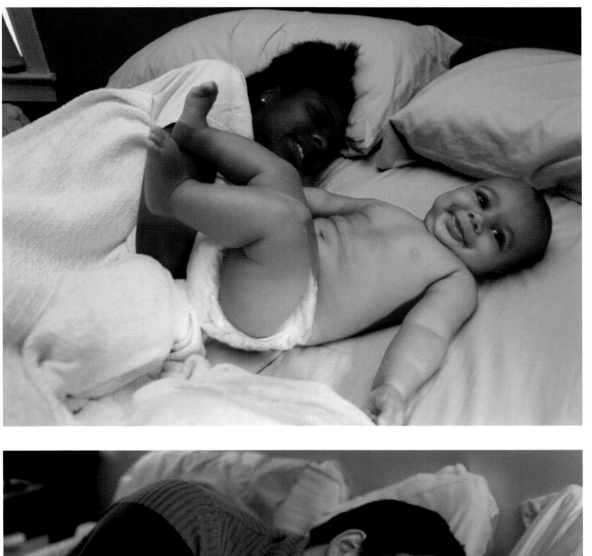

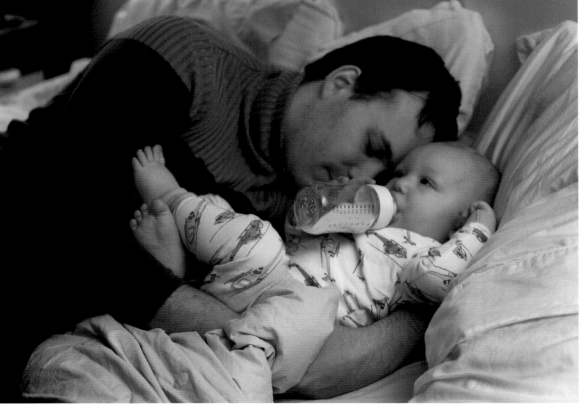

ATLANTA
An instinct to play distracts Maya Webster from collecting eggs in her backyard. Her family's chicken coop houses a rooster and three chickens, or "Jerry and the girls," as Maya's dad James calls them. The Websters live in the Cabbagetown District, not far from the State Capitol.
Photo by Tova R. Baruch

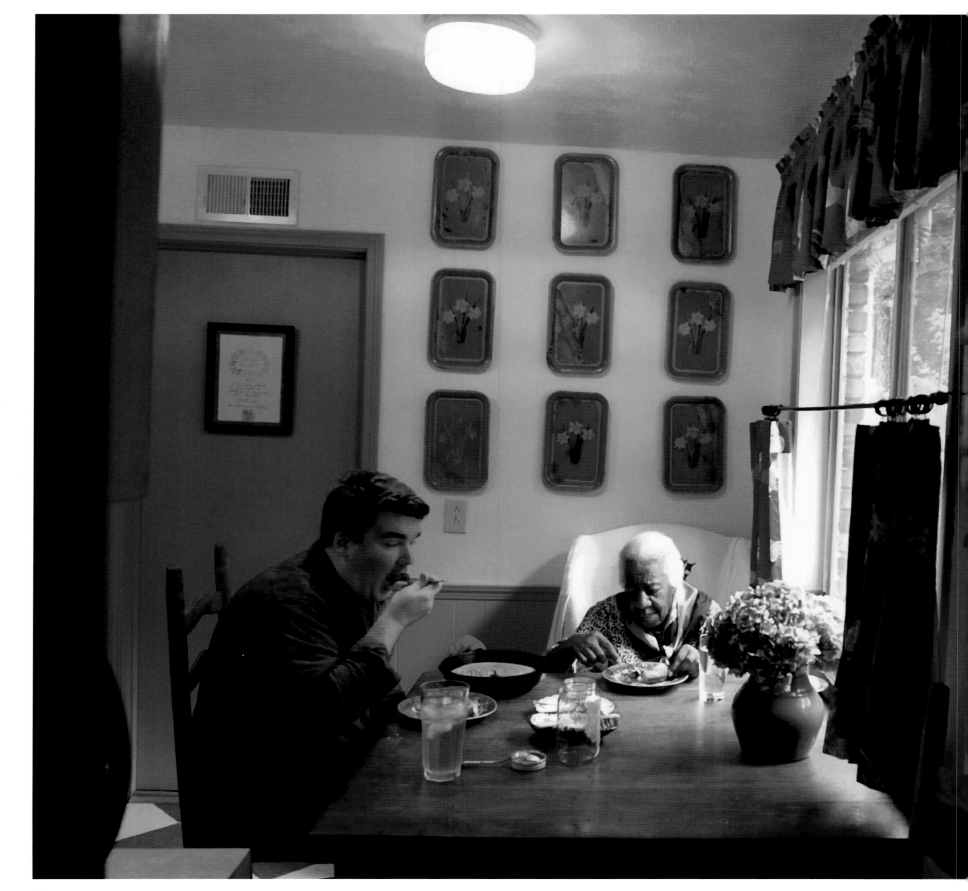

DECATUR

When chef Scott Peacock met the grand dame of Southern cooking, Edna Lewis, at a party 15 years ago, their mutual love of Southern food drew them together. A friendship blossomed. The 40-year-old Alabama native and the 87-year-old Virginian became roommates in 1999—an arrangement that has fostered culinary collaboration. Last year they coauthored the bestseller *The Gift of Southern Cooking.*
Photo by Joey Ivansco

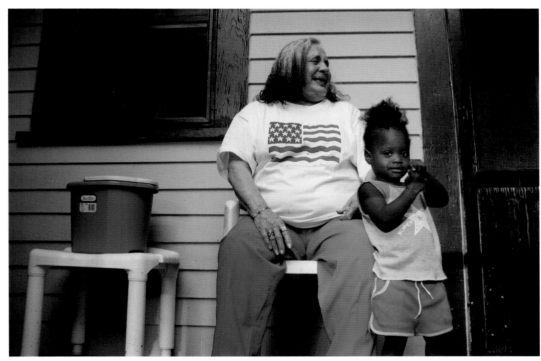

ATLANTA

The Cabbagetown District, east of downtown, originally sprang up around the Fulton Bag and Cotton Mill, built in 1881. Gentrification, though, took hold in the 1990s when the abandoned mill was converted to lofts and the neighborhood's worker cottages were snapped up. A few long-time residents like Elsie Hunter still hang on.
Photo by Tova R. Baruch

ATLANTA
Lilli Kim Ivansco melts into a daytime bath while musing over 11 Down (answer: "Elmer").
Photo by Joey Ivansco

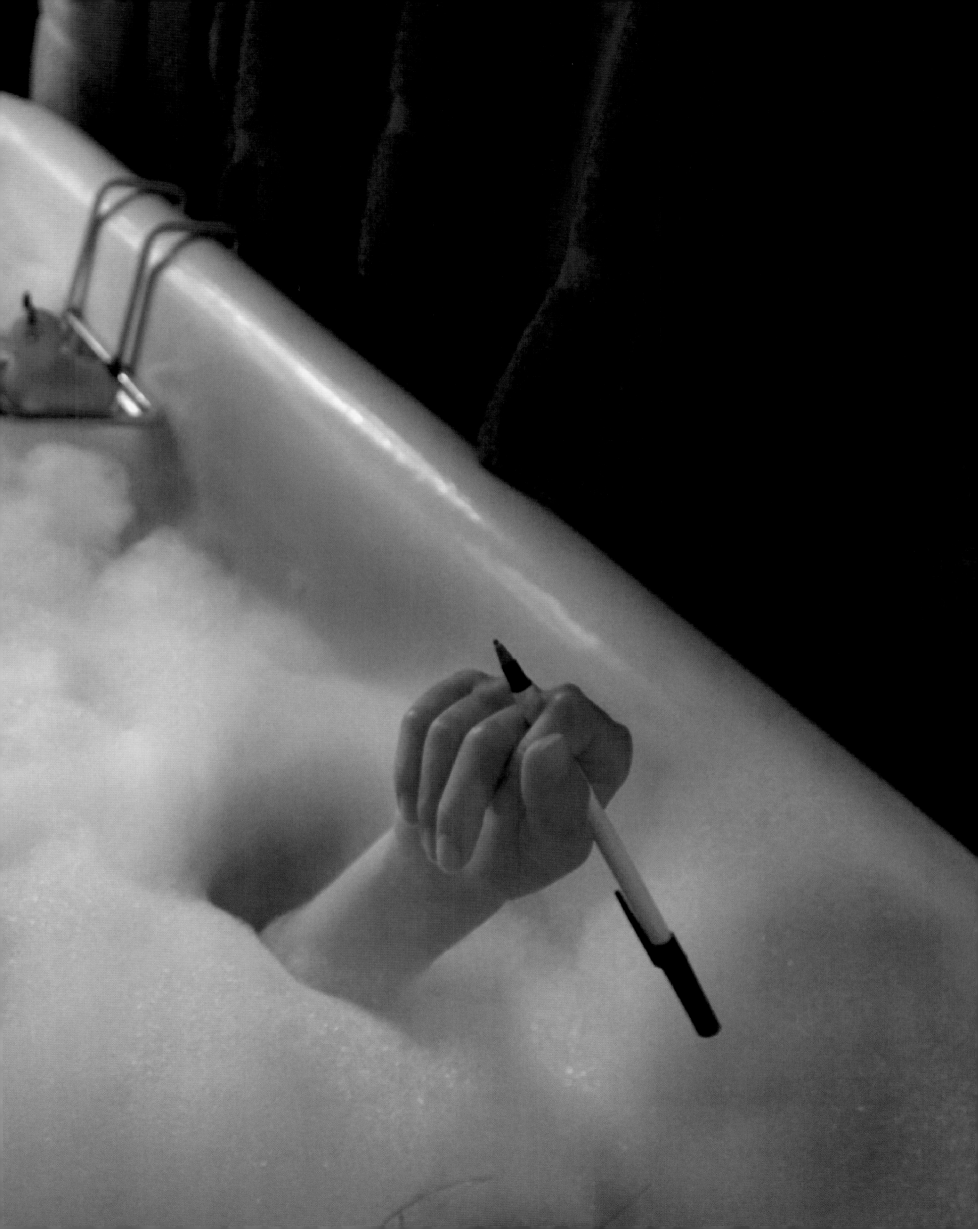

ATLANTA

Rena Marroquin, director of financial services at the Art Institute of Atlanta, spends the weekend installing insulation in a Habitat for Humanity home in South Atlanta. The new house is one of the 42 that Atlanta Habitat plans to build in 2003, with the help of more than 10,000 volunteers.

Photos by Andrew Niesen

ATLANTA

Volunteers Jim Branan and Mike O'Sullivan nail roofing material to a Habitat house. Since 1976, Habitat has built 45,000 homes in the United States.

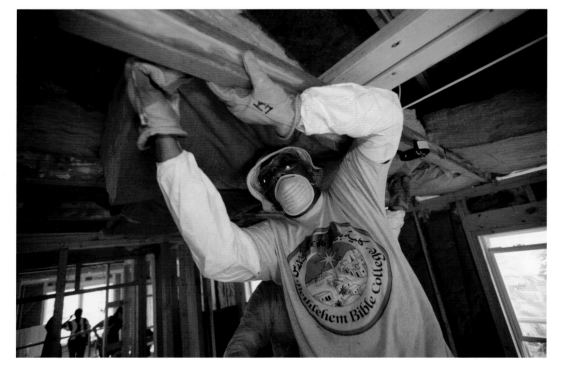

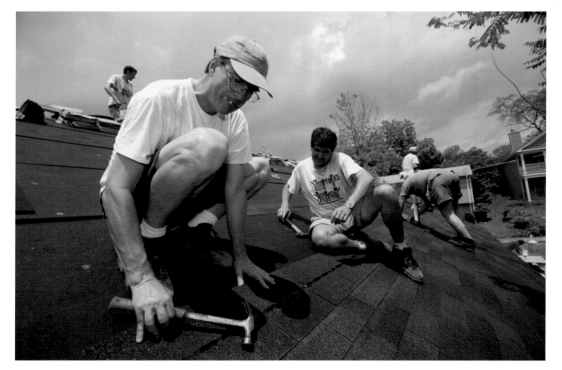

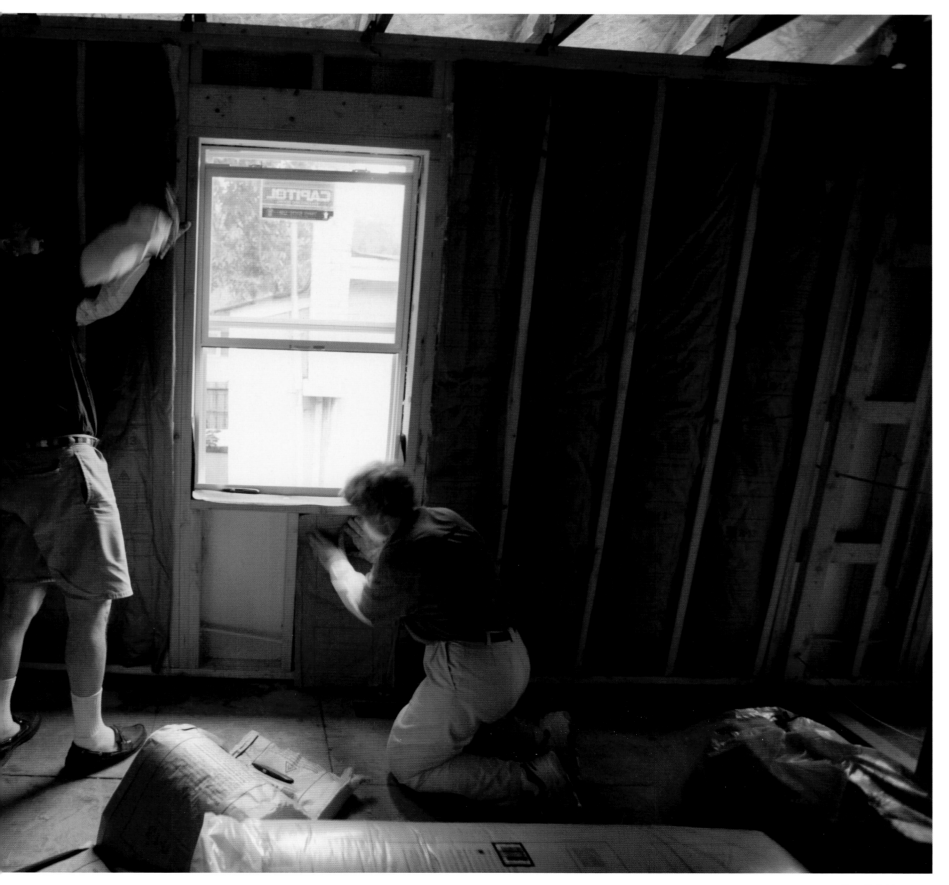

ATLANTA
Volunteers install windows in an upstairs bedroom of a Habitat house that takes 35 people seven weekends to construct. Home buyers invest 250 hours of "sweat equity" and end up with a home of their own for under $100,000 and mortgage payments of no more than $500 per month.

MADISON

It's a point of pride in the antebellum town of Madison that General Sherman spared its great homes on his March to the Sea.
Photos by Gene Driskell

CLAYTON

Eleven years ago, custom furniture maker Dwayne Thompson built a miniature house from hand-cut logs for his young daughter Anne. The place served its purpose and then some. "A friend who got too drunk to make it home slept there one night," Thompson explains. "But Anne never did."
Photo by Gene Driskell

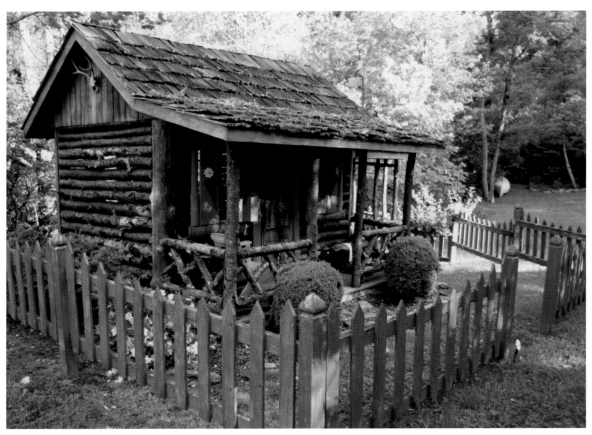

MADISON

The Victorian-era Hunter House on Main Street allowed plenty of porch for lemonade afternoons. The Madison Chamber of Commerce claims this is the most photographed house in the world.
Photo by Gene Driskell

MACON

Located in a historic section of downtown, the Horne-Bridge-Herring house was built in 1890. It was a single-family dwelling until 1964, when it was converted into four apartments. Many Maconites are unhappy with the current "out-of-character" paint job.
Photo by Pete Nicholls

"We wanted a Southern-style wedding," said the bride, Christy Word of Dallas, who got her wish. Her ceremony took place on a hot and muggy afternoon making the party favors—fans painted with magnolias—a necessity for her 100 guests. Groom Jason Word employed his while waiting for his bride to reach the altar and here, while preparing for their portrait.
Photos by Joey Ivansco

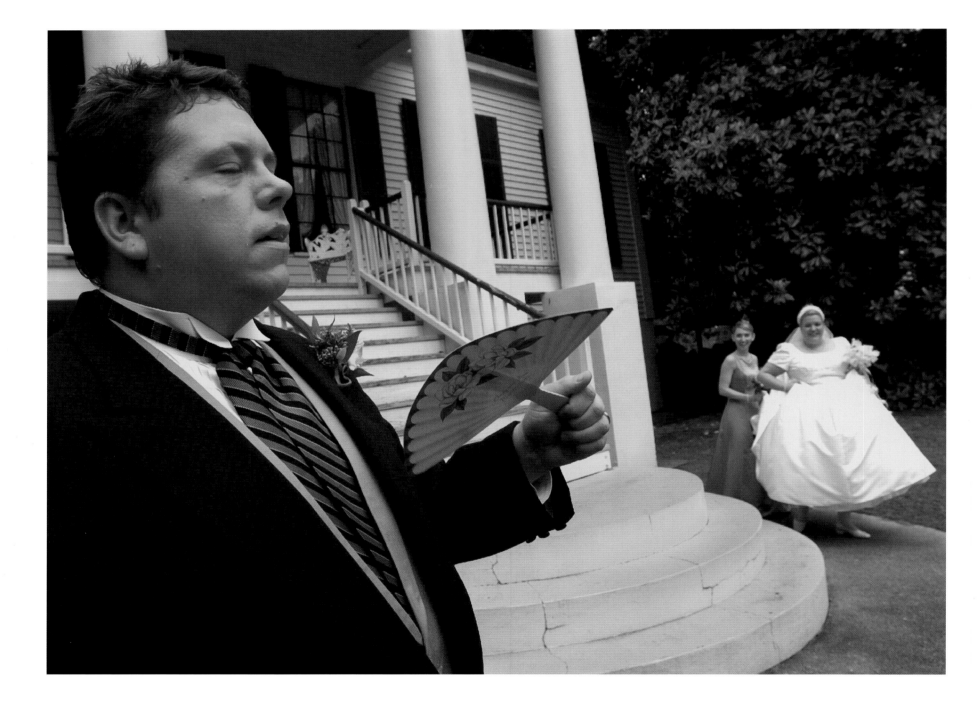

STONE MOUNTAIN

Groomsmen swelter in rented Ralph Lauren wool suits, waistcoats, and ascot ties during Christy and Jason's wedding at the antebellum plantation house in Stone Mountain Park. Bridesmaids Keva Miller (left) and Amanda Levine stayed cool in A-line satin dresses. Tuxedo jackets were the first clothing to go at the couple's reception aboard a side wheel riverboat.

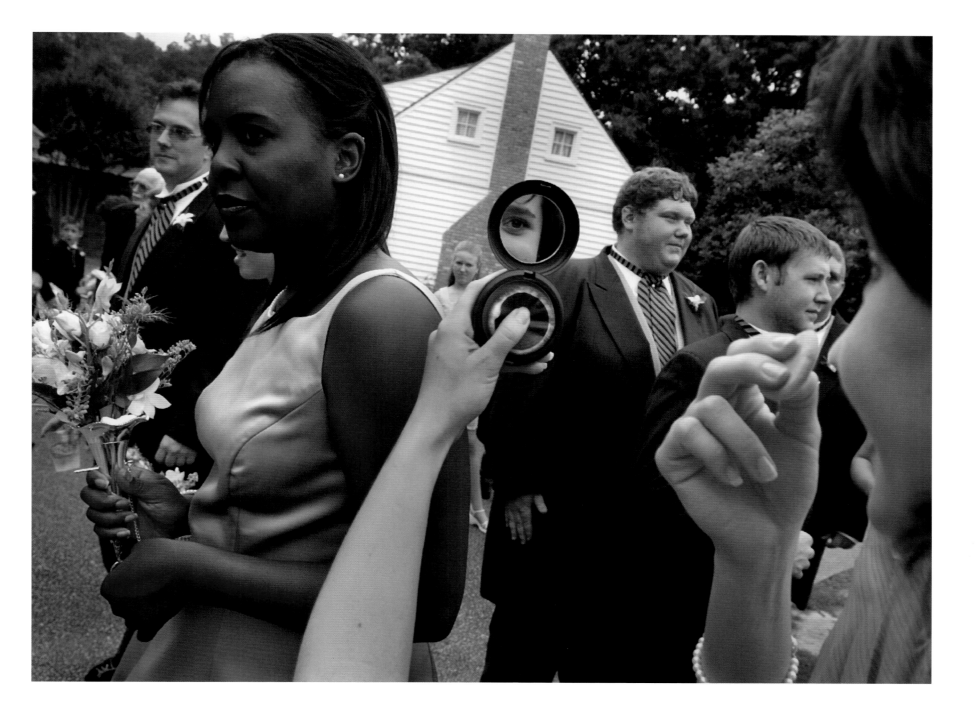

MONROE

Incarcerated at Walton County Jail, Jamie Thomas, Amy Jones, and Teresa Bumbalough make the best of their situation. The jail holds up to 26 women, who are not required to stay in cells during the day. The inmates can hang out in the dayroom and talk on the phone or they can go outside to play basketball.

Photo by Jennifer Bowen Braswell

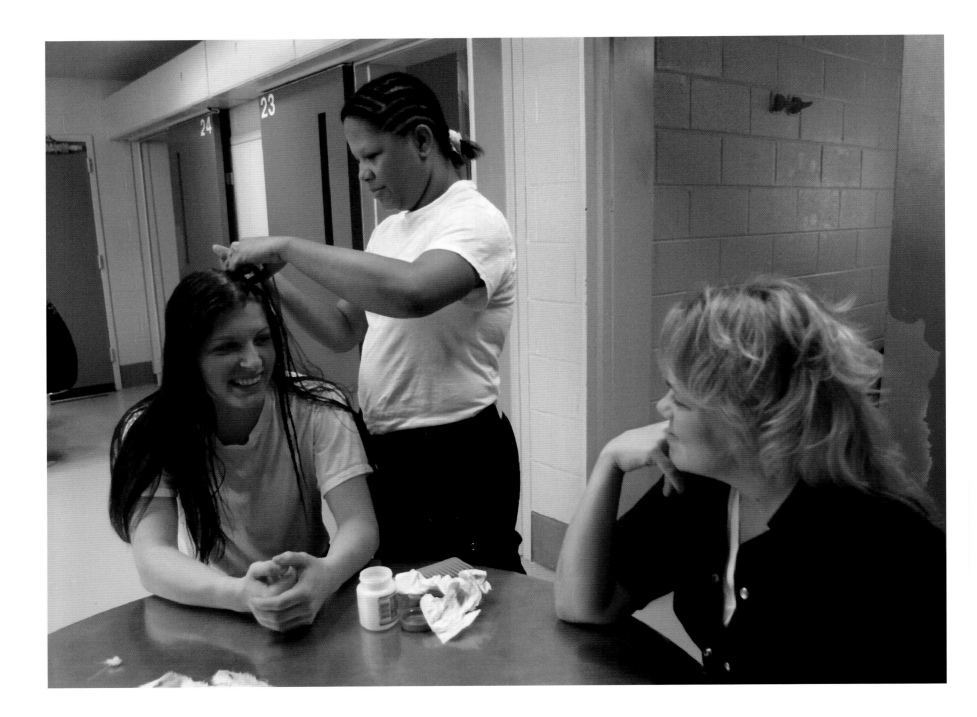

ATLANTA

Louise Scheuer, 91, cools off with a cold bottle of Diet Coke while her perm sets at Mozelle's Hair Care. Scheuer's been coming to the midtown salon every week for 40 years. The loyal client prefers to have her hair styled the old-fashioned way—with hot rollers, oldies radio, and lots of chitchat.

Photo by Joey Ivansco

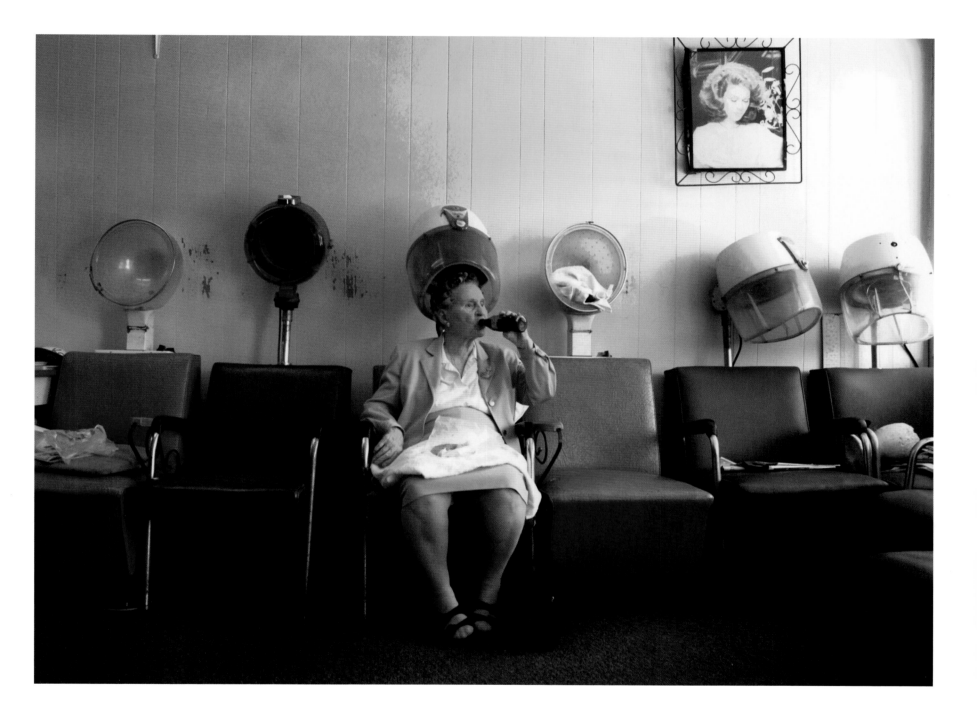

FAIRBURN

When he was 10 years old, Evander Holyfield walked into a gym, heard the slap of leather on leather and knew what he wanted to do with his life. Thirty years later, the four-time world heavyweight boxing champion is newly married and luxuriously ensconced in a 51,000-square-foot mansion on 400 acres in the countryside outside of Atlanta.
Photo by Greg Foster

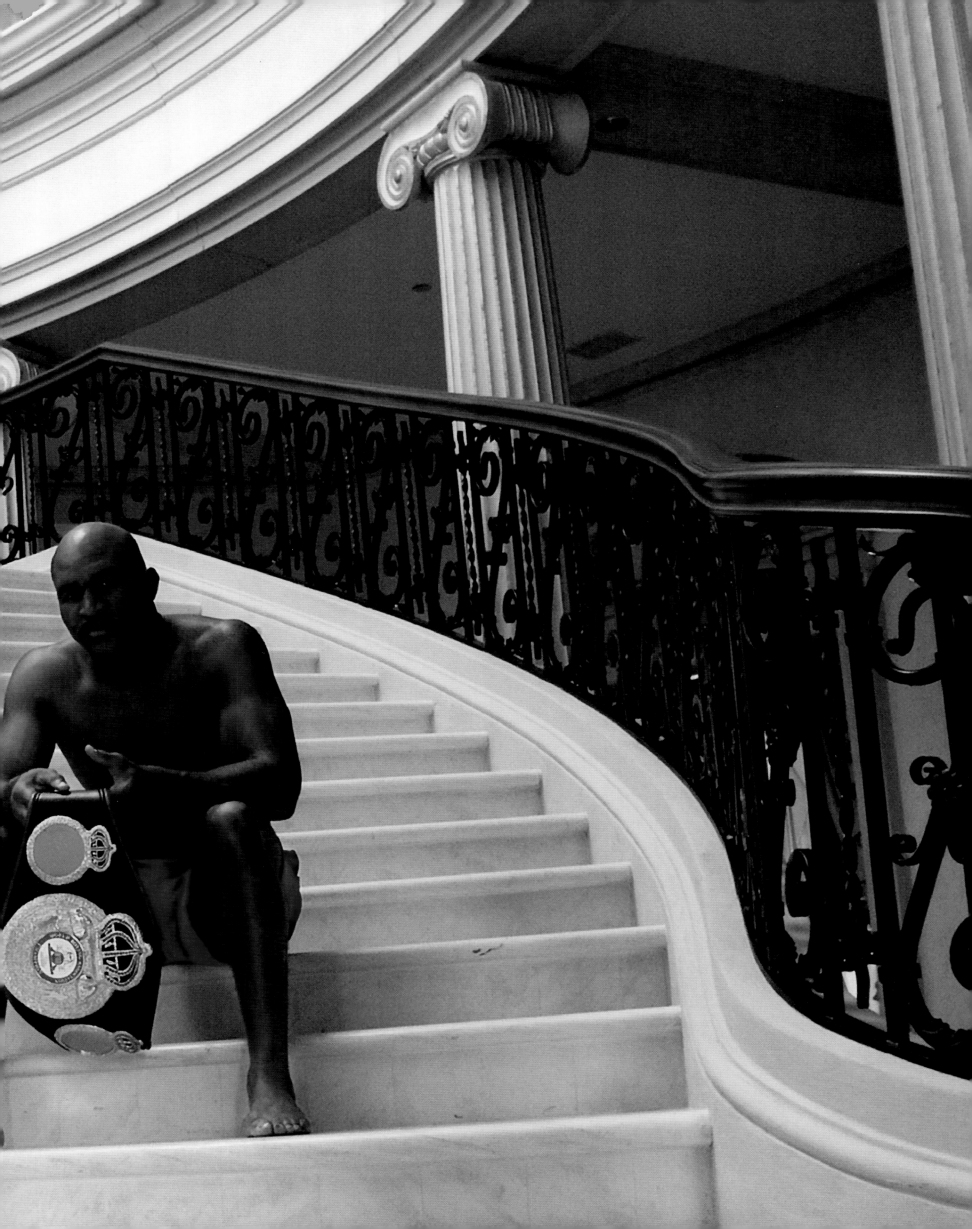

The year 2003 marked a turning point in the history of photography: It was the first year that digital cameras outsold film cameras. To celebrate this unprecedented sea change, the *America 24/7* project invited amateur photographers—along with students and professionals—to shoot and, via the Internet, submit digital images. Think of it as audience participation. Their visions of community are interspersed with the professional frames throughout this book. On the following four pages, however, we present a gallery produced exclusively by amateur photographers.

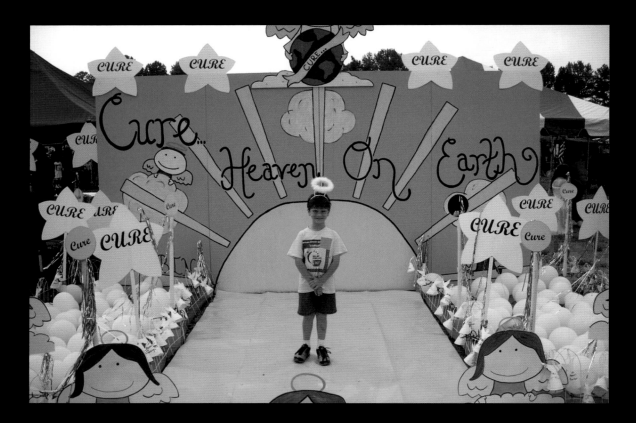

LAWRENCEVILLE Devon Stayt, 7, is honorary chair for the American Cancer Society's Gwinnett 2003 Relay for Life. Diagnosed with non-Hodgkin's lymphoma when he was 5, Devon endured six months of chemotherapy, and after a year his doctors consider him cured. *Photo by Mark Stayt*

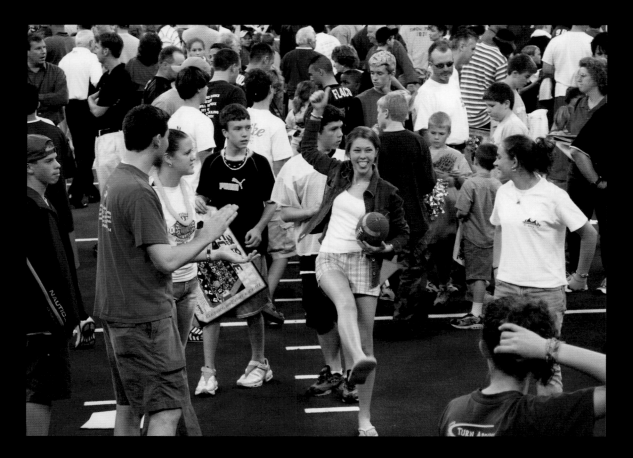

ATLANTA It was reason enough to celebrate when the Georgia Force beat the Tampa Bay Storm. But when the two Arena Football League teams invited the crowd onto the field, fans were simply over the moon. *Photo by Carl Christie*

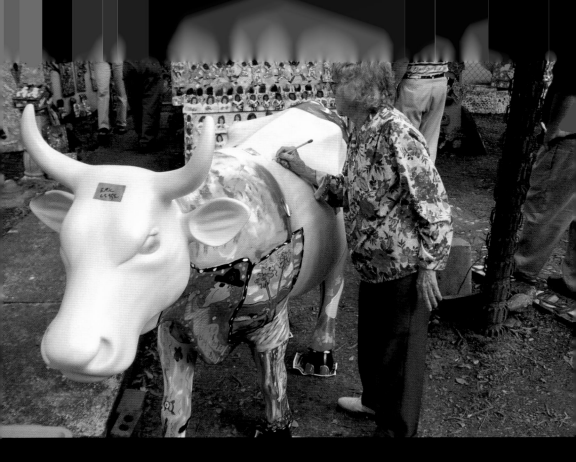

SUMMERVILLE Touched by an angel: Dealing with cancer, her daughter's murder, and a fire that destroyed her home, folk artist Myrtice West turned to religion and art for solace. Much of her work depicts angels, one of which she is painting on a cow for the CowParade Atlanta, a traveling exhibit touted by some as the world's largest public art exhibition. *Photo by Peter Loose*

COLUMBUS Pretty in pink: After a hard day in the classroom, 8-year-old Lydia Allen unwinds on the sofa with a

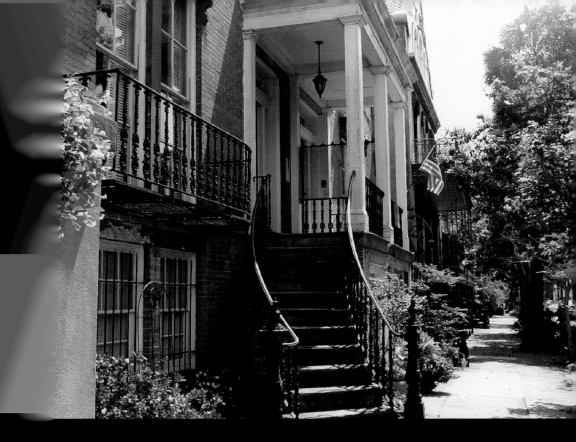

H The first planned American city, many of Savannah's 25 squares are bordered by stately row *hoto by Jeffrey Sowder*

NEGA The Wahsega 4-H Center started as a federally funded Civilian Conservation Corps camp during pression. The camp hired the unemployed to plant trees, construct roads and bridges, and build the flume ill shunts water from Ward Creek to a pond on the center's property. *Photo by Matthew Williamson*

LOGANVILLE Just off highway 78 in Walton County, the old homestead on the Boss family farm has served seven generations. With town names like Between and Social Circle, the 329-square-mile county lies halfway between Atlanta and Athens. *Photo by Virginia Holland*

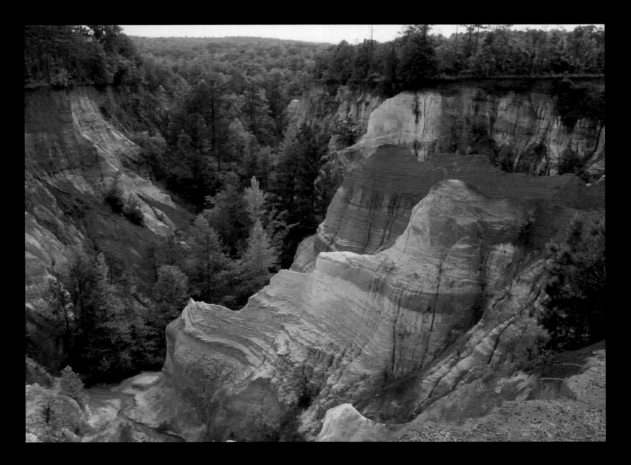

LUMPKIN When early pioneers cleared Stewart County's pine trees for cotton farming, the sandy soil eroded into 150-foot canyons, now part of Providence Canyon State Park. *Photo by James Davidson*

FORT BENNING

Two hundred of Fort Benning's annual class of 25,000 Army trainees undergo chemical weapons training. After removing their masks, Bravo Company recruits experience the stinging, burning, and choking sensations of CS gas exposure. "It's the same agent that our police force uses with just a little more kick," says Drill Sergeant Gregg Jonas.

Photo by Rich Addicks,
The Atlanta Journal-Constitution

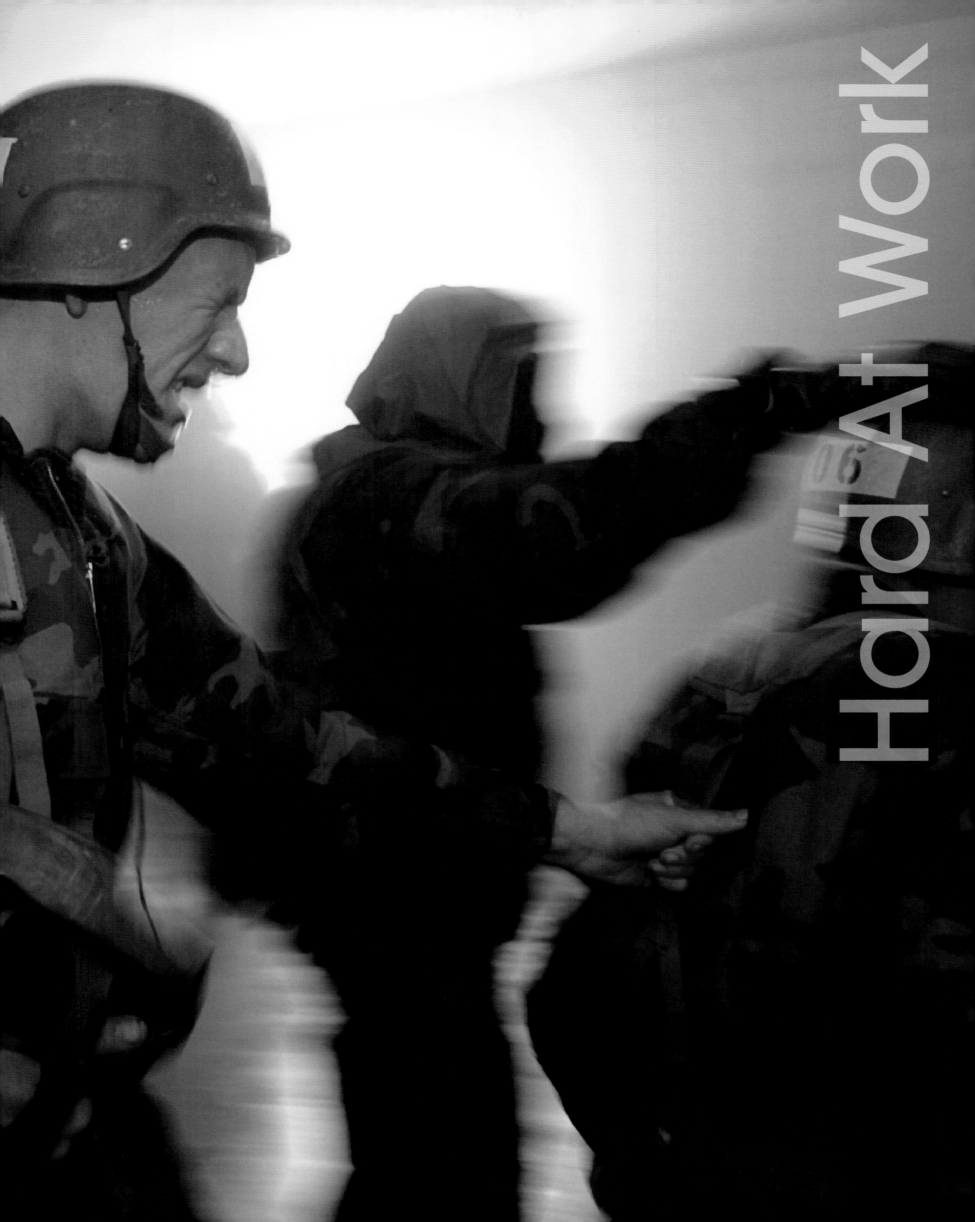

Hard At Work

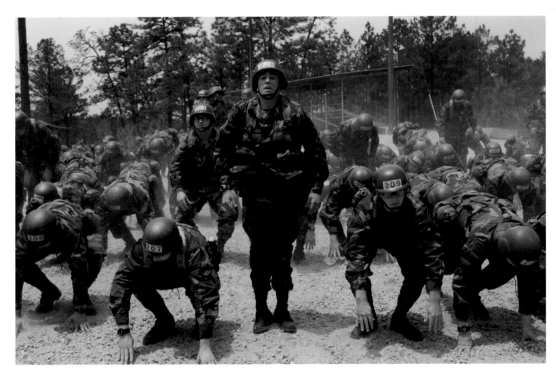

FORT BENNING

A small infraction committed by a few members of the Bravo Company during lunch break means the entire regiment will pay the price with running and squatting drills. By midday, the rigors of boot camp are starting to take their toll.

Photos by Rich Addicks,
The Atlanta Journal-Constitution

FORT BENNING

Before combat simulation exercises, trainees learn to camouflage their faces and weapons to blend in with Fort Benning's pine and hardwood forests. Officers teach recruits to shade prominent facial areas (forehead, chin, nose) with dark paint and naturally darker, recessed areas (eyes and lower cheeks) with green hues.

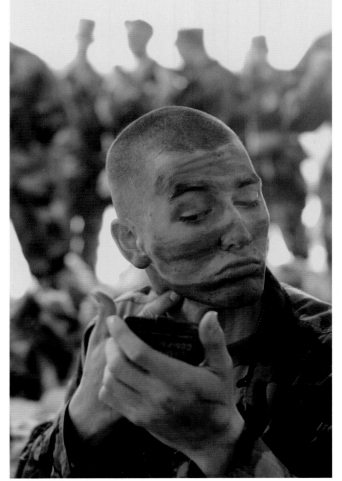

FORT BENNING

At daybreak, the bleary-eyed Bravo Company begins its first physical training exercise of the day: consecutive sets of push-ups, sit-ups, and group runs. Army infantry training is intense, exhausting—and effective. Most new recruits score only 90 points out of 300 on the Army Physical Readiness Test. By graduation, their average score jumps to 275.

GRIFFIN
Just north of Griffin city limits, Georgia State
Patrol trooper John McMillan takes aim at speed-
ers in the southbound river of traffic on Highway
19-41. "Laser radars are great for busy roads," says
the officer. In Spalding County, 2,900 drivers were
ticketed for speeding in 2003.
Photo by Greg Foster

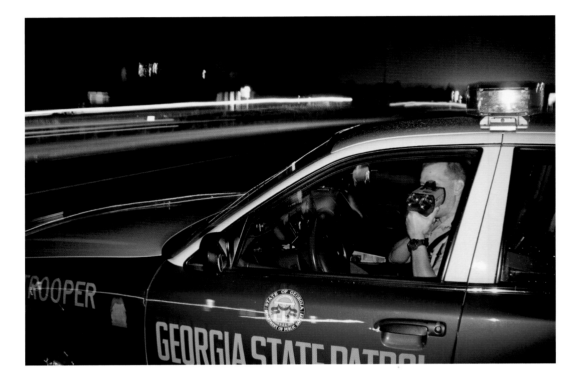

TUCKER

Vernia Guthrie inspects up to 600 flags each day at Atlas Flags. Most of the product is classic stars and stripes in various sizes, but Texas and Confederate flags are frequent special orders, she says. Guthrie's well-trained eye rarely misses an imperfection—she's been with the company for 25 years.

Photo by Joey Ivansco

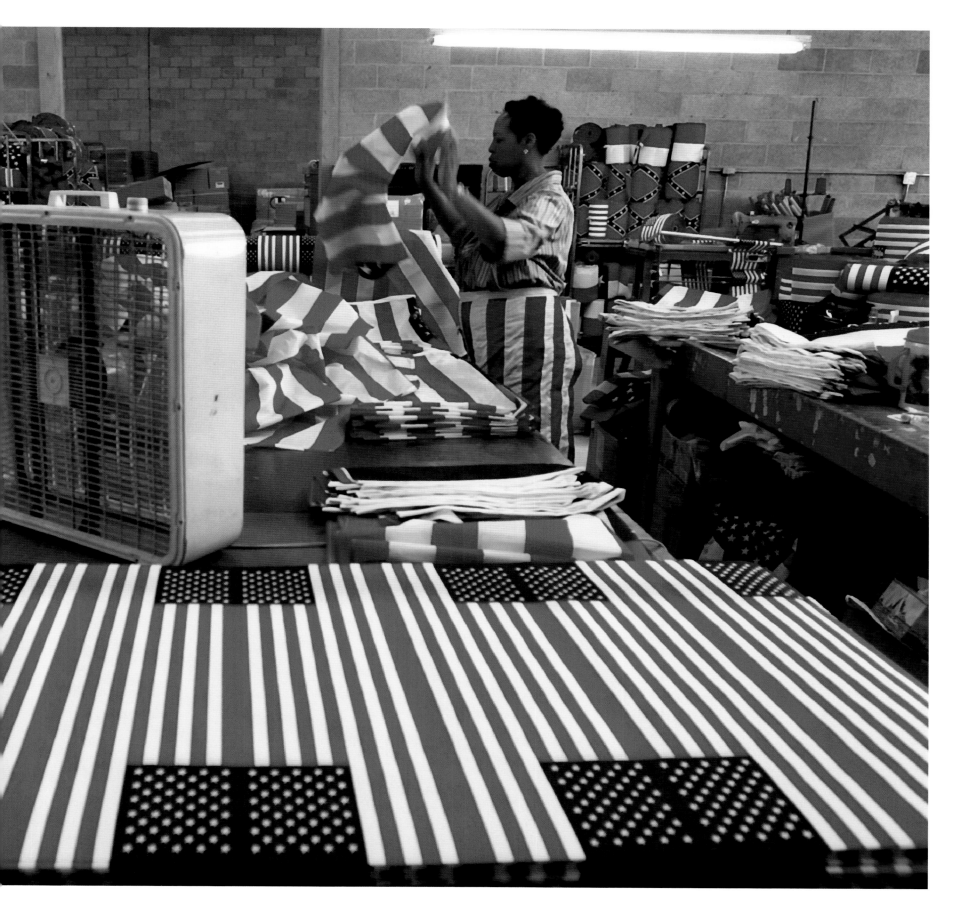

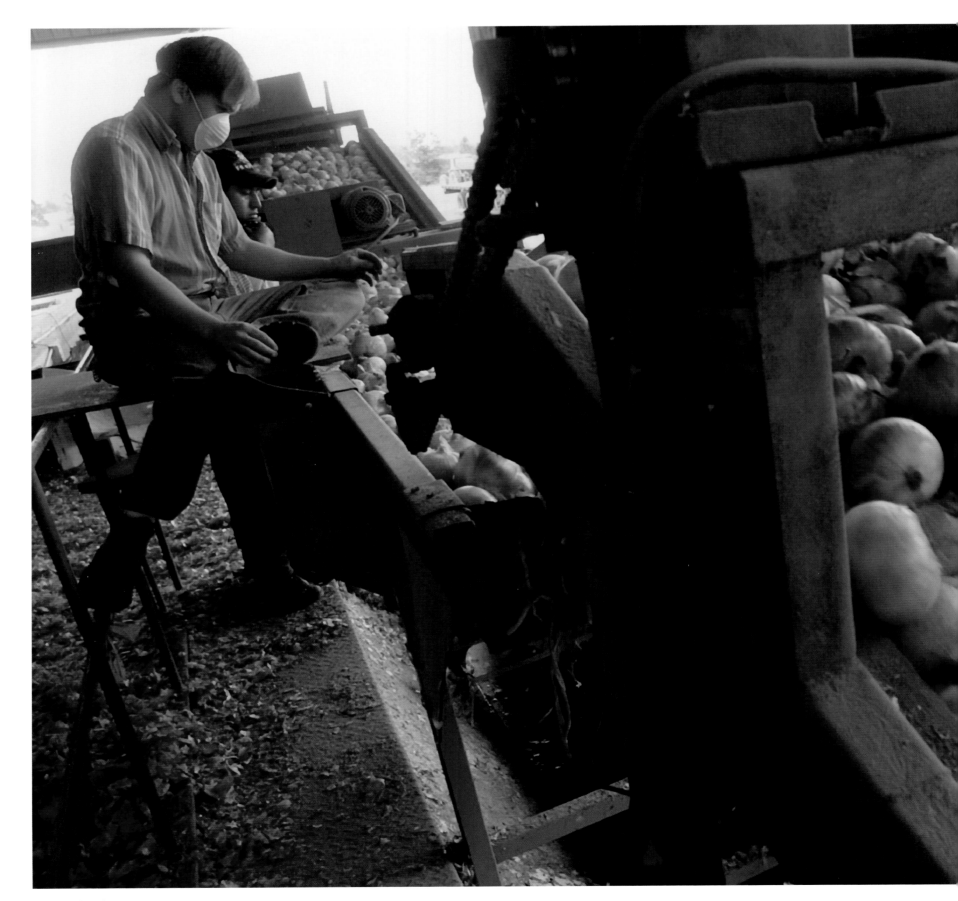

VIDALIA
Georgia's famous Vidalia onions took root in Toombs County in 1931 when Mose Coleman discovered that the local climate and soil produced onions that were more sweet than sharp. Grading machines at Stanley Farms sort Vidalias by size, while graders keep an eye out for spoilage.
Photos by Jonathan Ernst

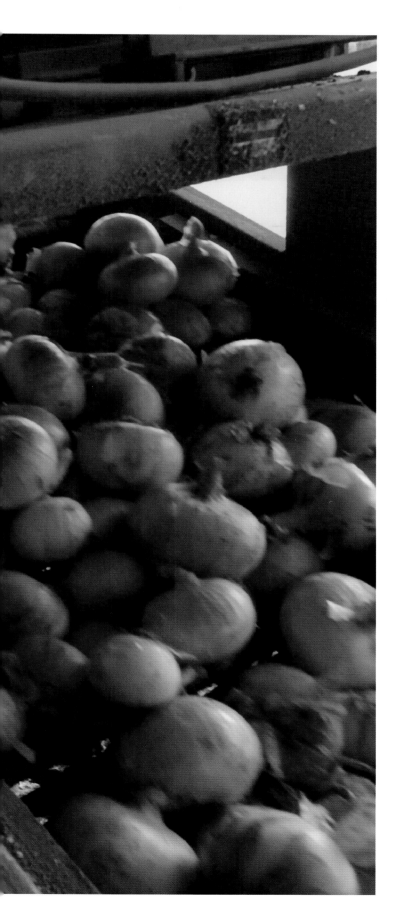

LYONS

Hundreds of bags of harvested onions await pick up at Cowart Farm. An estimated 15,000 acres of central Georgia are planted with Vidalia onions each year. The onions are dug up and left to dry for two to three days in the field. Then, the tops and roots are clipped, and the onions bagged for shipping.

ANDERSON CITY
After three years of drought and low commodity prices, things are looking up for Jerald Carter. He is hopeful that 2003 will be a good year for his three crops: cotton, peanuts, and corn. Spring rains helped stalks shoot up to shoulder height by May, and analysts predict a bumper peanut crop.
Photo by Rich Addicks,
The Atlanta Journal-Constitution

KEYSVILLE
Georgia's ubiquitous red clay soil makes its strawberries extra sweet. For $7.50, folks can pick a gallon of the fruit at the Strawberry Patch owned by Bonita and Jim Myers.
Photo by Jonathan Ernst

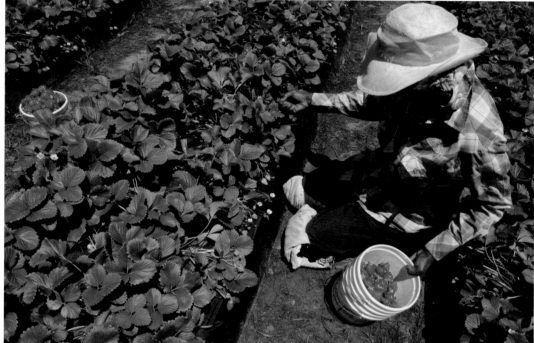

KINGS BAY
Crew members of the nuclear submarine USS *West Virginia* get a "Drive and Dive" refresher course at the Trident Training Facility. The control room simulator can pitch to an angle of 35 degrees, duplicating the physical experience of diving and surfacing.
Photo by Flip Chalfant

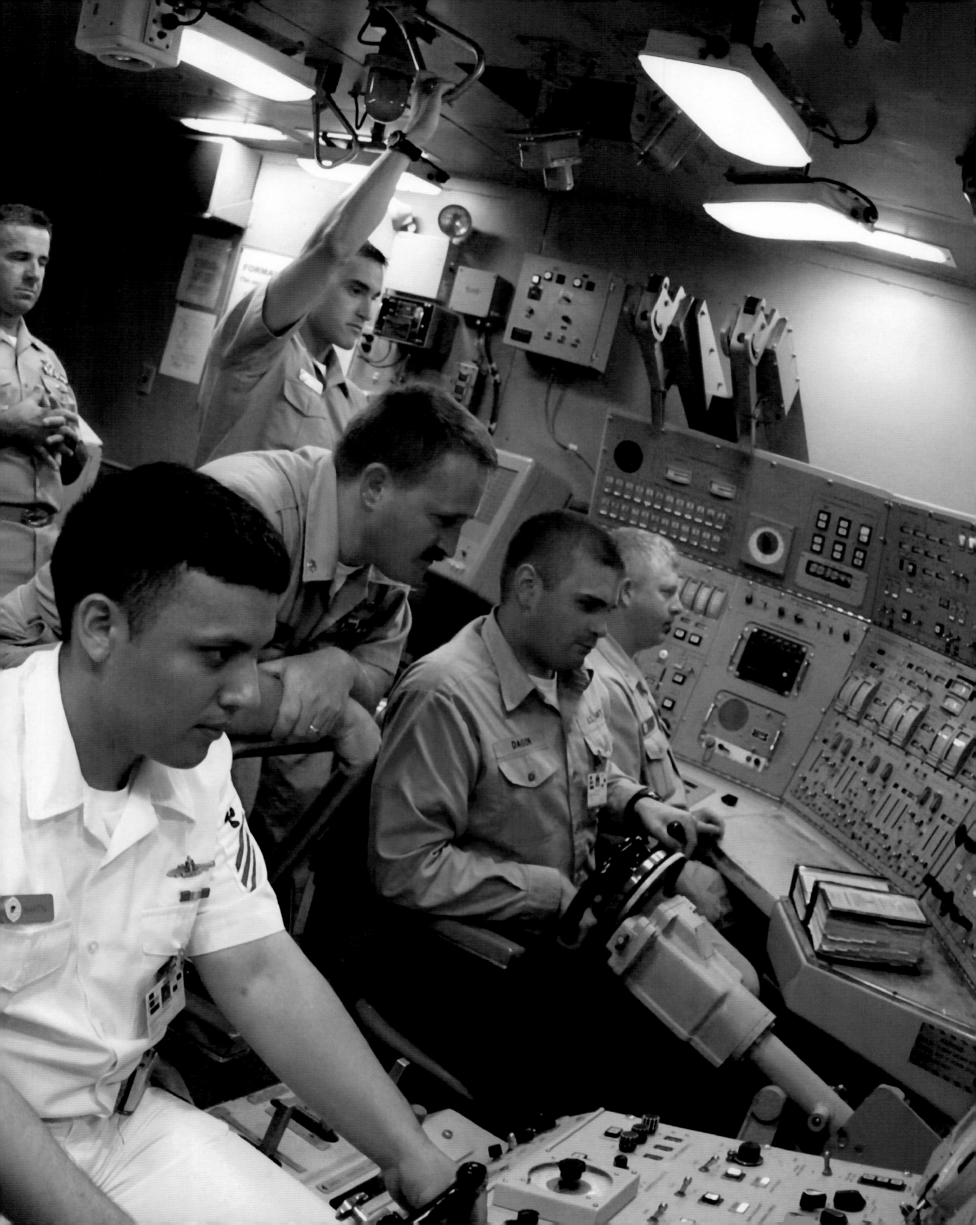

Pilot-boat Captain Jeff Glenn accompanies an auto cargo ship out of Brunswick Harbor. On board the freighter, a bar pilot steers the vessel through the channel. Once the big ship is safely in deep water, Cpt. Glenn will collect the bar pilot from the ship in a tricky maneuver using a rope ladder. "When it's rough, it's dangerous," he says.
Photo by Stephen Morton, stephenmorton.com

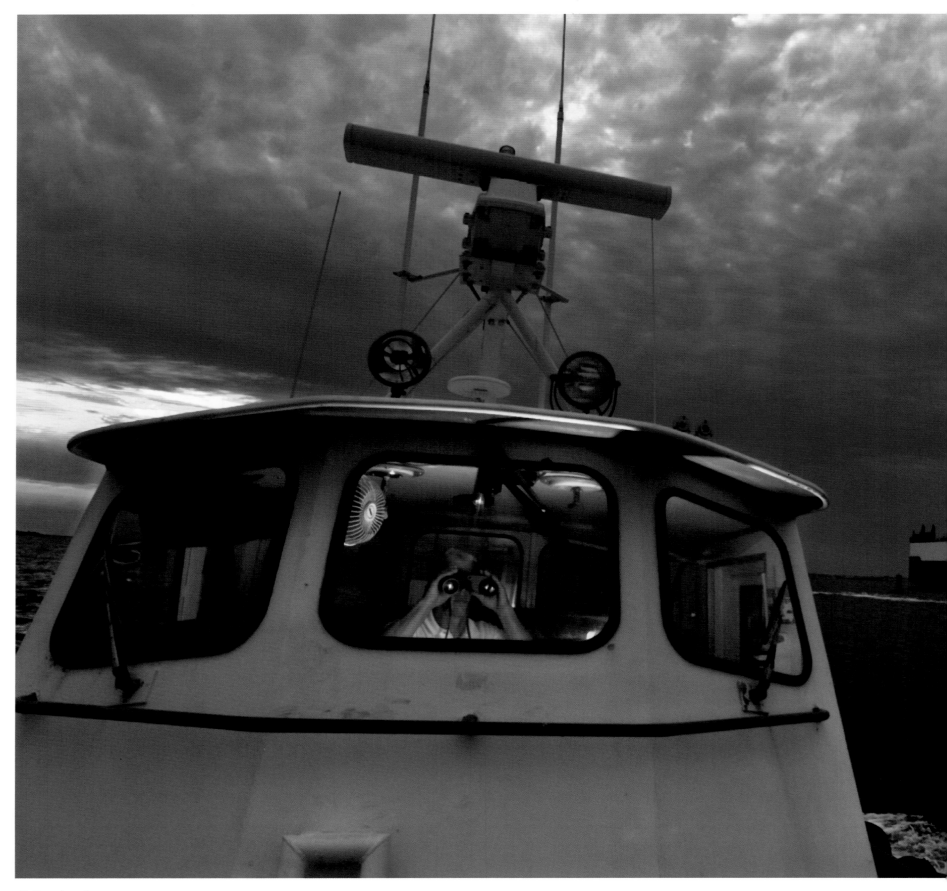

ATLANTA
On CNN's national desk, assignment editor Jeff Salzgeber devours wires and websites, burning up the phone lines to gather and sift information for compelling news stories. "The assignment desk is like a buffet of information the producers can choose from," he says. "The key is a network of local reporters."

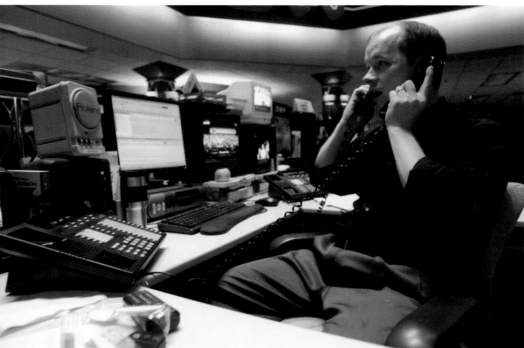

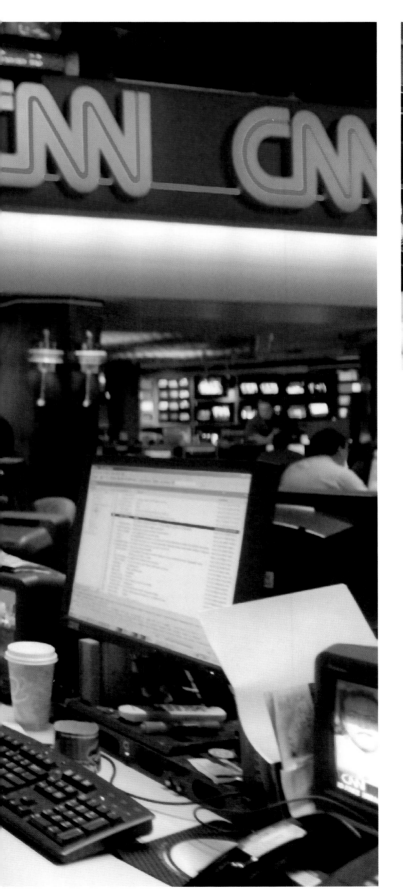

ATLANTA

Twenty-five photographers paid $150 to hear wedding photography guru Denis Reggie explain the science of pretty pictures during a seminar at Four Seasons Hotel. The Atlanta-based photographer's portfolio includes the weddings of John F. Kennedy, Jr., Arnold Schwarzenneger, and designer Vera Wang.

Photo by Philip Gould

DECATUR

When a rare strain of viral meningitis, known as echovirus 13, swept the country in 2001, microbiologist William Allan Nix began searching the Centers for Disease Control and Prevention's archives for samples collected during an earlier outbreak. He continues comparing historical strains to the virus's current manifestation in hopes of tracking its genetic evolution.

Photo by Sunny H. Sung,
The Atlanta Journal-Constitution

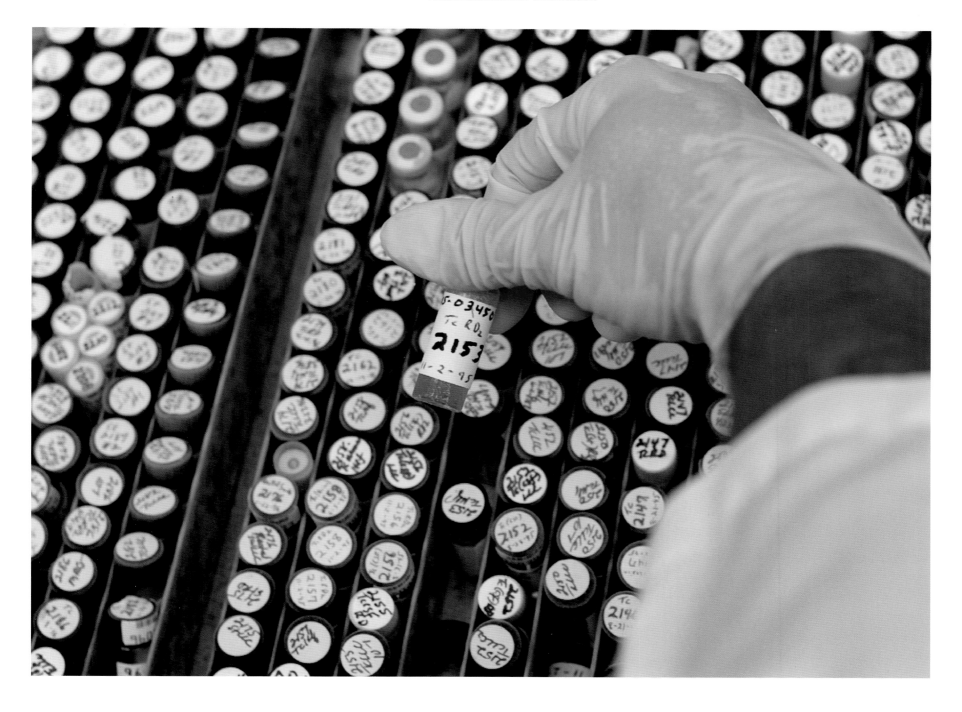

ATLANTA
Speed isn't the problem for fearless 15-year-old Nash Addicks and his noble steed, Chipper. Rather, it's how to stop.
Photo by Rich Addicks,
The Atlanta Journal-Constitution

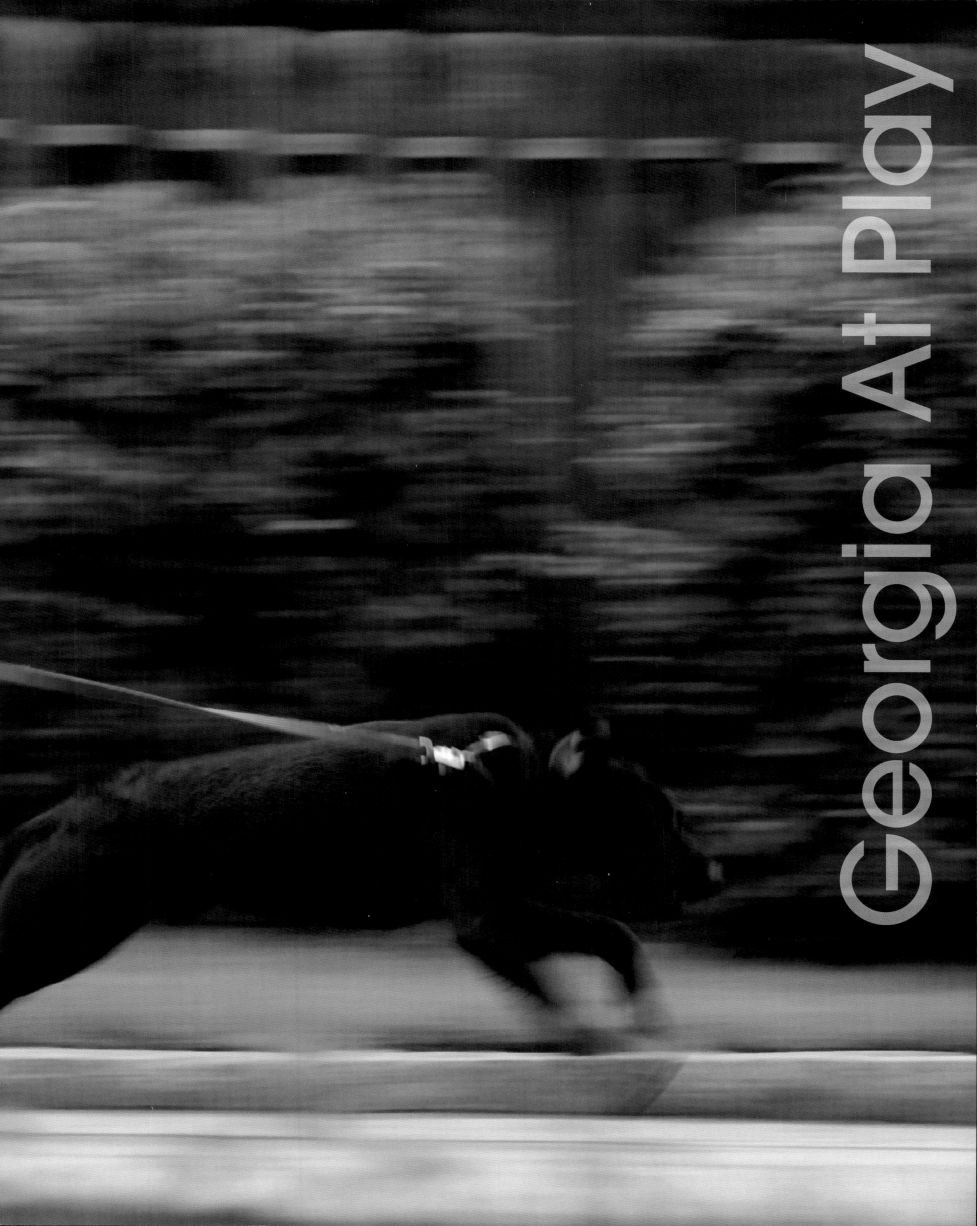

Georgia At Play

ATLANTA

Meghan Byrne and Pumpkin, her Australian shepherd, jog through 88 acres of gravestones and mausoleums at the Oakland Cemetery. Southern legends Margaret Mitchell and Bobby Jones are buried here, as are 3,000 Confederate soldiers. "I like that connection of past and present," says Byrne. "It's a very calming place."
Photo by Joey Ivansco

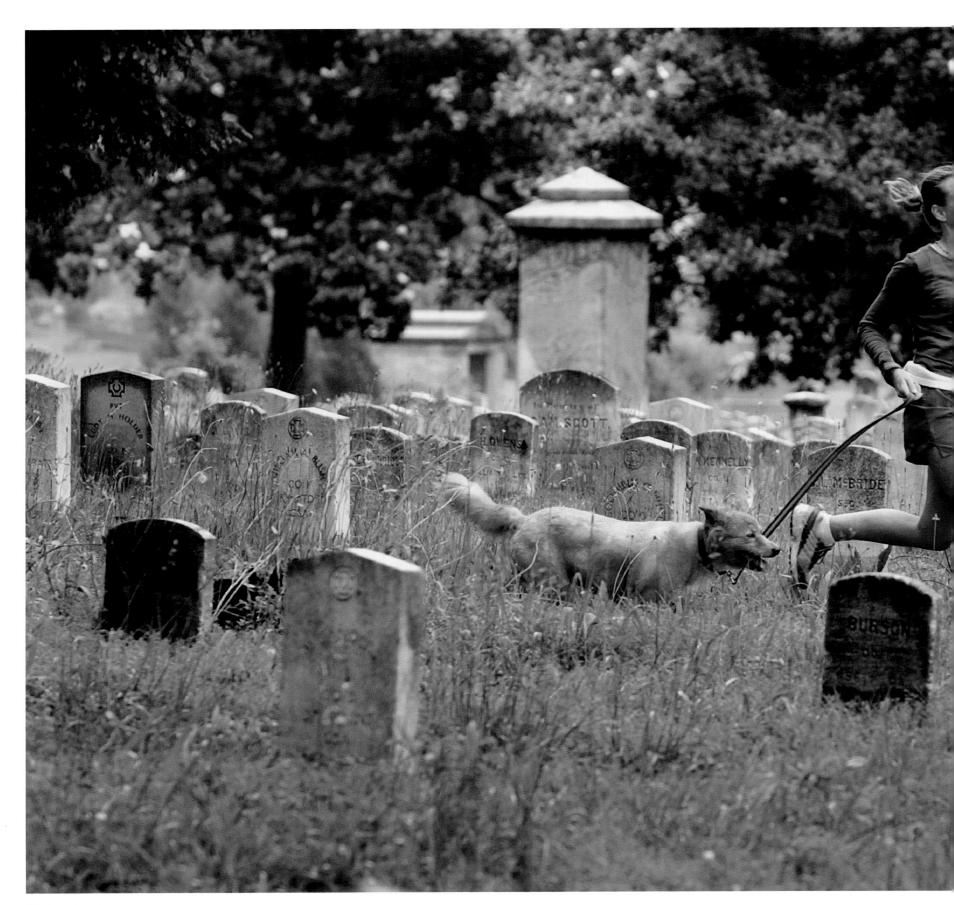

STONE MOUNTAIN

A thick fog keeps Jordan Bryan from seeing anything but his own reflection in a series of vernal pools at the top of Stone Mountain. On a clear day, the view includes the sprawling Atlanta metropolis and the plains of the Piedmont stretching to the horizon.

Photo by Joey Ivansco

ATLANTA

The track at the Crunch Fitness Center in the city's Buckhead neighborhood circles two full basketball courts. Not all Georgians are health conscious though: the obesity rate among Georgia adults increased by 118 percent from 1990 to 2002, with 59 percent of adults classified as obese and 33 percent of middle school children overweight.

Photo by Jamie Squire

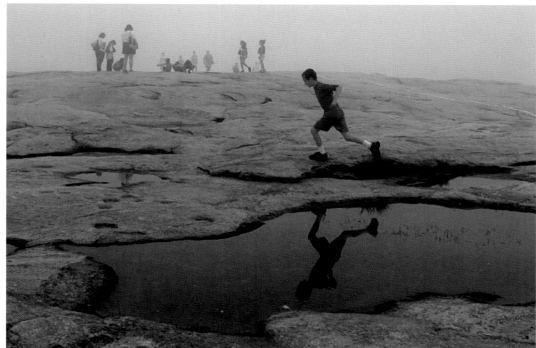

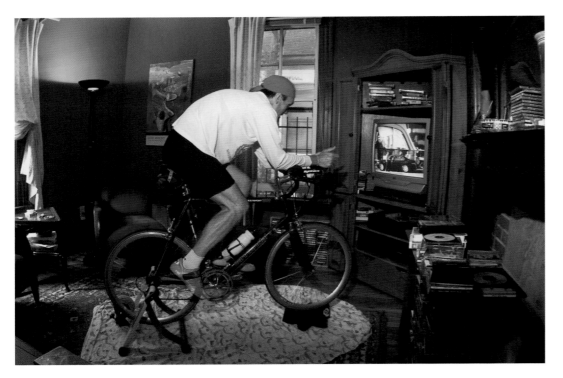

ATLANTA

Training for a Half Ironman triathlon, public defender Jeff Ertel logs 120 miles a week on the bike, many of those before and after work. Ertel started doing triathlons after a bout with cancer and chemotherapy. "A friend forced me into it to get me up and moving," he says. "At the time, I couldn't run for two minutes."

Photo by Steven Schaefer

GRIFFIN

"We're a family-oriented establishment. No liquor's sold here," says Marvin Mills (right), Pete's Pool Room manager. The hall opens at 8:30 a.m. for a cast of regulars that include four gentlemen in their 80s who have been coming to Pete's to shoot pool for 40 years.
Photo by Greg Foster

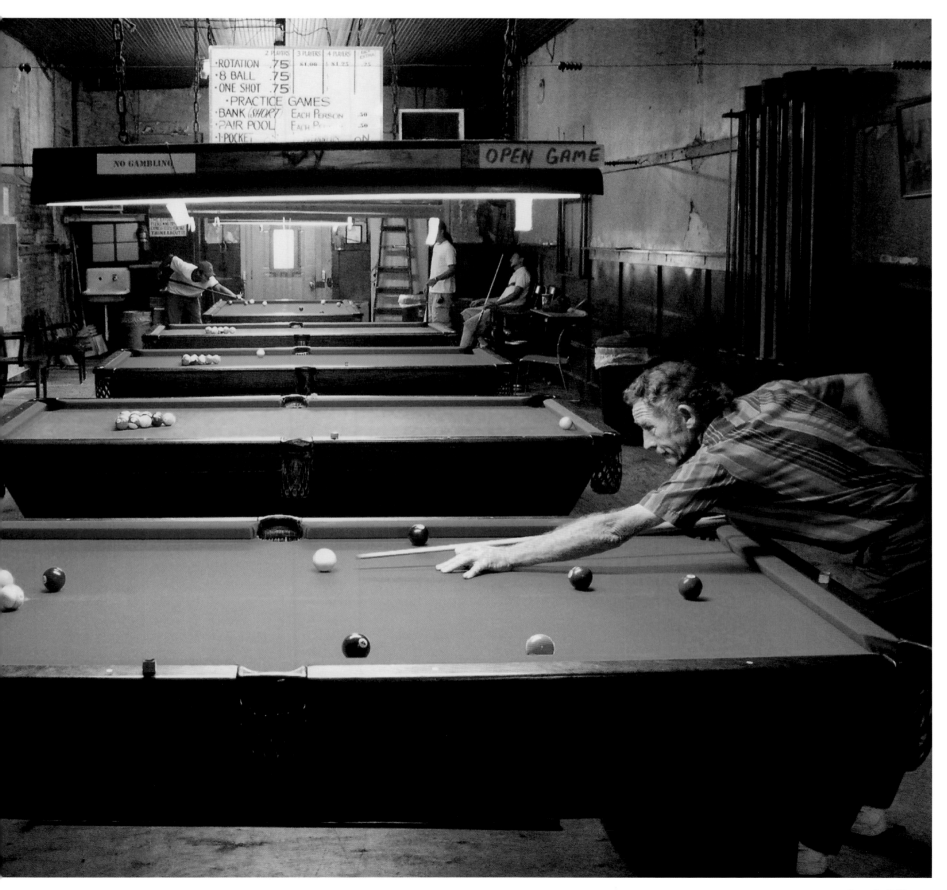

Chris Quinn takes a detour off the Etowah River to explore an oak-and poplar-shaded backwater. The *Atlanta Journal-Constitution* reporter paddled seven miles down the Etowah during the Coosa River Basin Canoe-A-Thon, a fundraising event for river basin cleanup efforts.
Photo by Sunny H. Sung,
The Atlanta Journal-Constitution

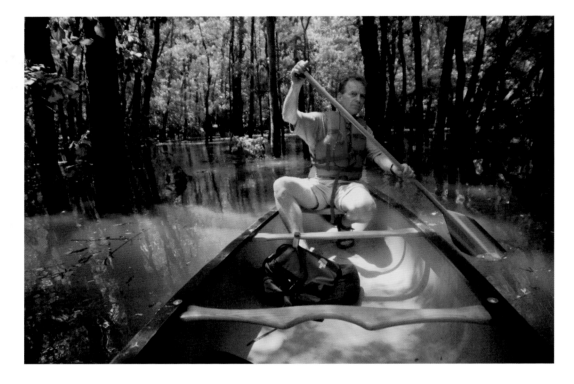

ROSWELL

Beginning as a trickle near the Tennessee border, the Chattahoochee River spills southward past Atlanta, where it serves as a welcome playground for city dwellers.

Photo by Tami Chappell

ATLANTA
Catalan sculptor Xavier Medina Campeny created this dramatic steel billboard of Martin Luther King, Jr. for installation along Freedom Parkway in downtown Atlanta. The profile of the civil rights leader is cut from a curved steel plate measuring 10-by-18 feet.
Photo by Jean Shifrin

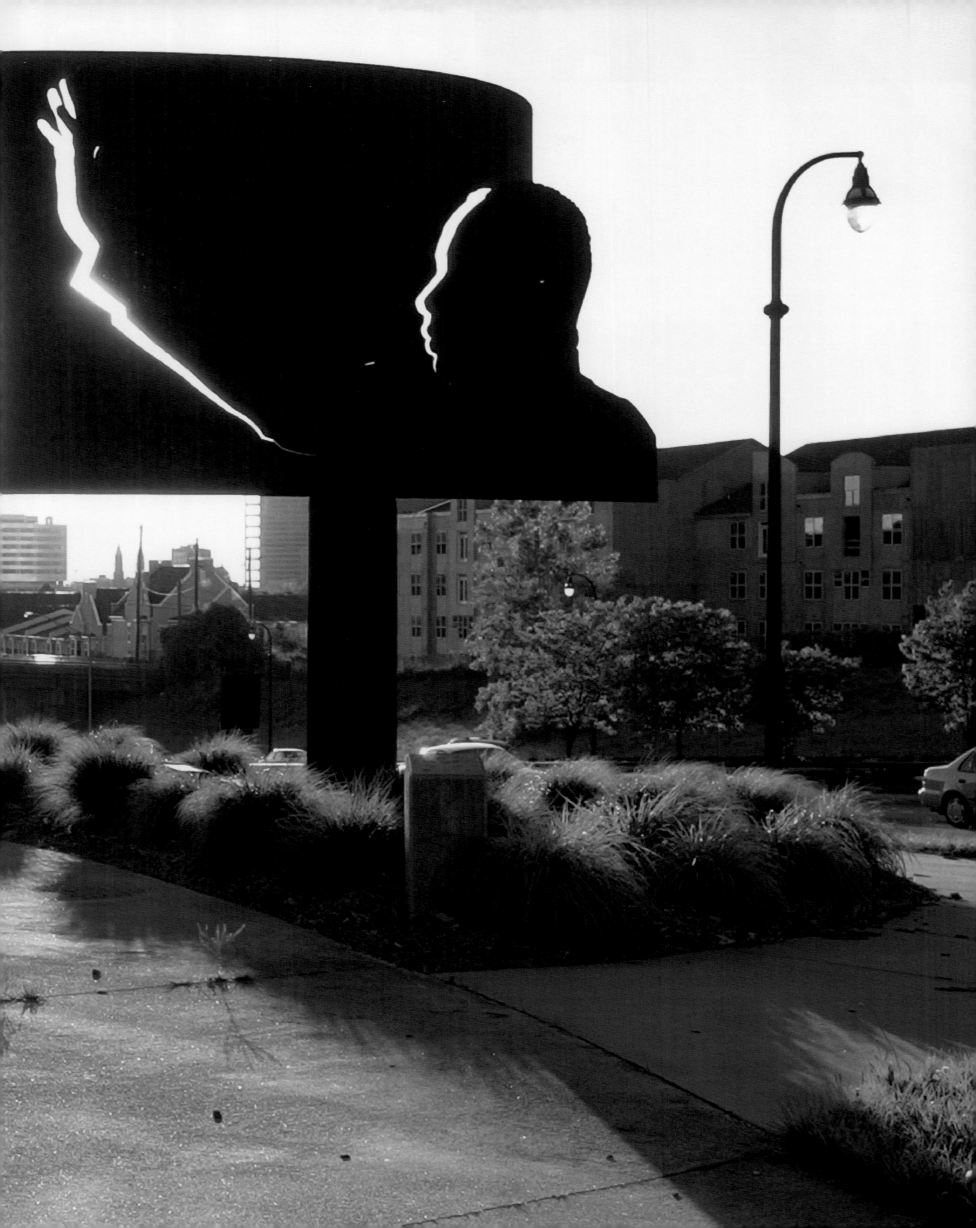

OSSABAW ISLAND
Department of Natural Resources interns Jamie
Gibbs and Jay Chupp cover a lot of ground to doc-
ument the nests of endangered sea turtles on
Georgia's second-largest barrier island. Each year,
160 mature female loggerheads return to the
Ossabaw sands to nest. After depositing their
eggs, they return to the water, leaving the nests
vulnerable to predators for the two-month ges-
tation period.
Photo by Stephen Morton, stephenmorton.com

WINDER

Built in the early 1960s, Winder-Barrow Speed-
way's quarter-mile, banked-clay oval is home
to V-8 street stock car races from March to Sept-
ember. Preparing the track for a weekend of rac-
ing takes two days: Fresh dirt is trucked in, spread
out, wetted, and rolled. Purses are small; drivers
race for the love of the sport.

Photo by Ben Gray

ELBERTON

Redbreast sunfish, largemouth bass, black crappie, and channel catfish keep fishermen coming back to this stretch where the Savannah River widens, downstream from

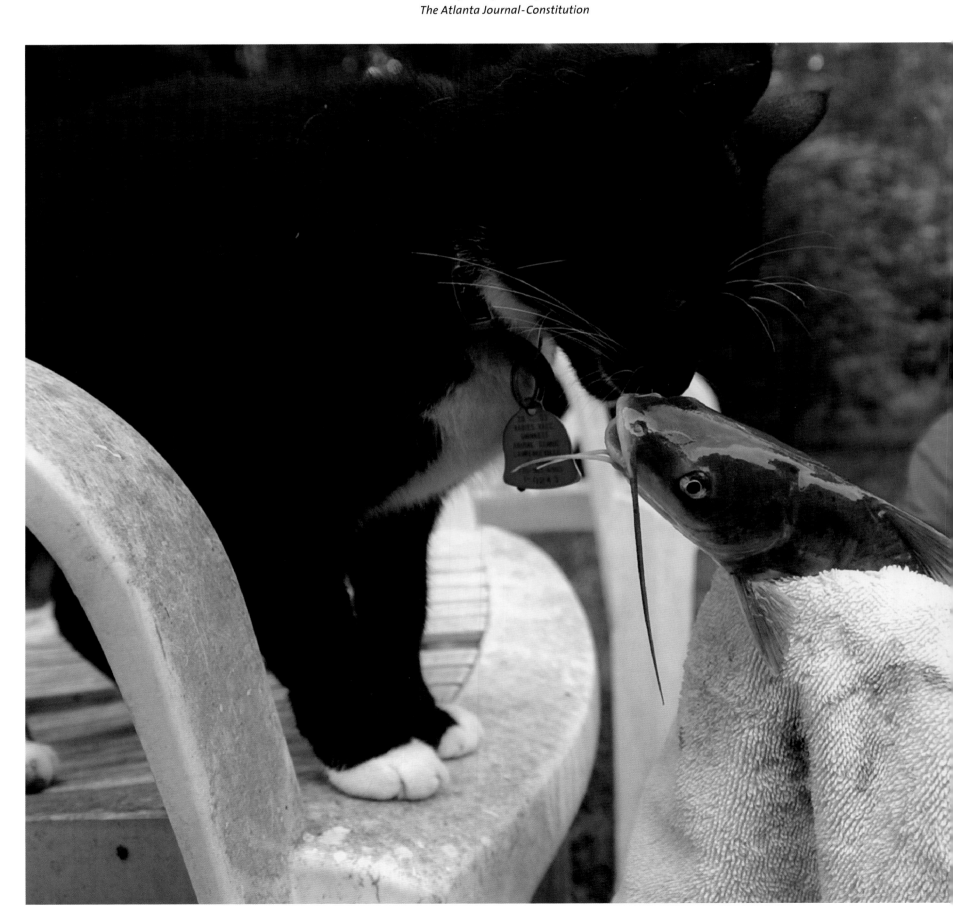

LAWRENCEVILLE
Something's fishy: Slippers the cat has met this catfish before. It's one of a few dozen that Jordan Garcia stocks in his backyard pond and catches with a hotdog-baited hook after school. Neither Slippers nor Jordan ever eat what Jordan nabs. The 14-year-old keeps his suburban fishing hole populated by catching and releasing the same fish over and over again.
Photo by Sunny H. Sung,
The Atlanta Journal-Constitution

ST. SIMONS ISLAND
Jody Van Buren and daughter Kirsten hang their fishing poles off St. Simons pier. Now a vacation destination, St. Simons Island was first settled by James Oglethorpe, an English army officer and prison reformer who arrived in 1733 to establish Georgia as the 13th British colony in North America.
Photo by Flip Chalfant

JEKYLL ISLAND
At high tide, Jekyll Island fishermen use a beach staircase as a jetty. Georgia's barrier islands endure a tidal range of 6 to 12 feet, second only to Maine's on the East Coast.
Photo by Flip Chalfant

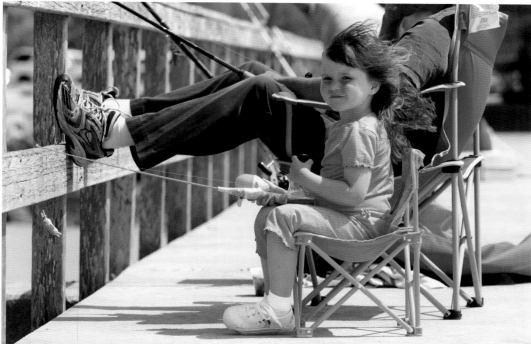

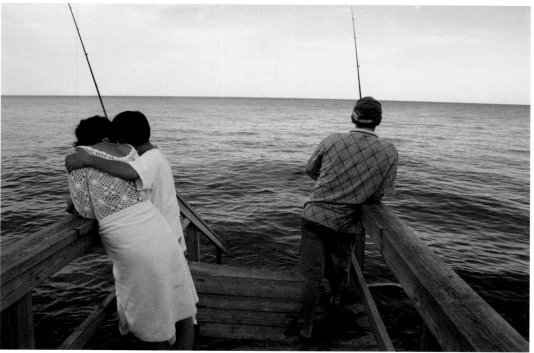

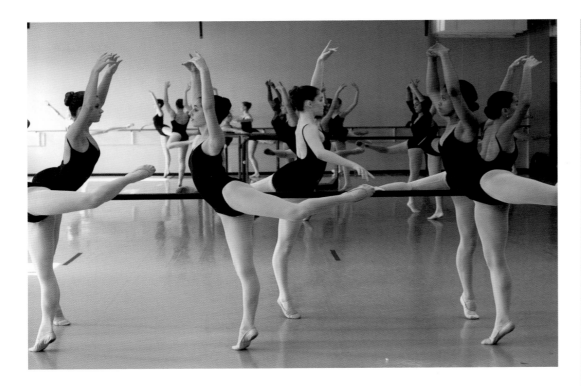

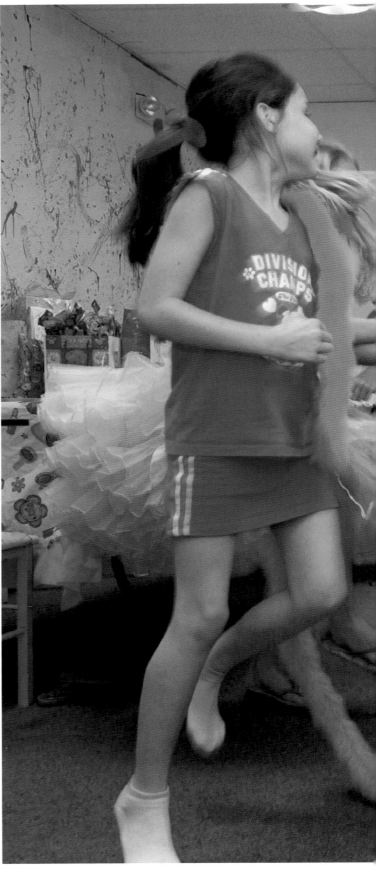

STOCKBRIDGE

Breanna Kelley, Audrey Greene, Kaitlynn Parrish, and Sarah Hodges flap their wings during the "Chicken Dance Song" at Kidz Plus Pamper Parlor & Apparel Boutique. The 8-year-olds were pampered at a birthday party, where they played dress-up and got manicures and pedicures. Owner Lisa Harris offers the parties, she says, because "kids are stressed out these days and need to enjoy life."
Photo by Jean Shifrin

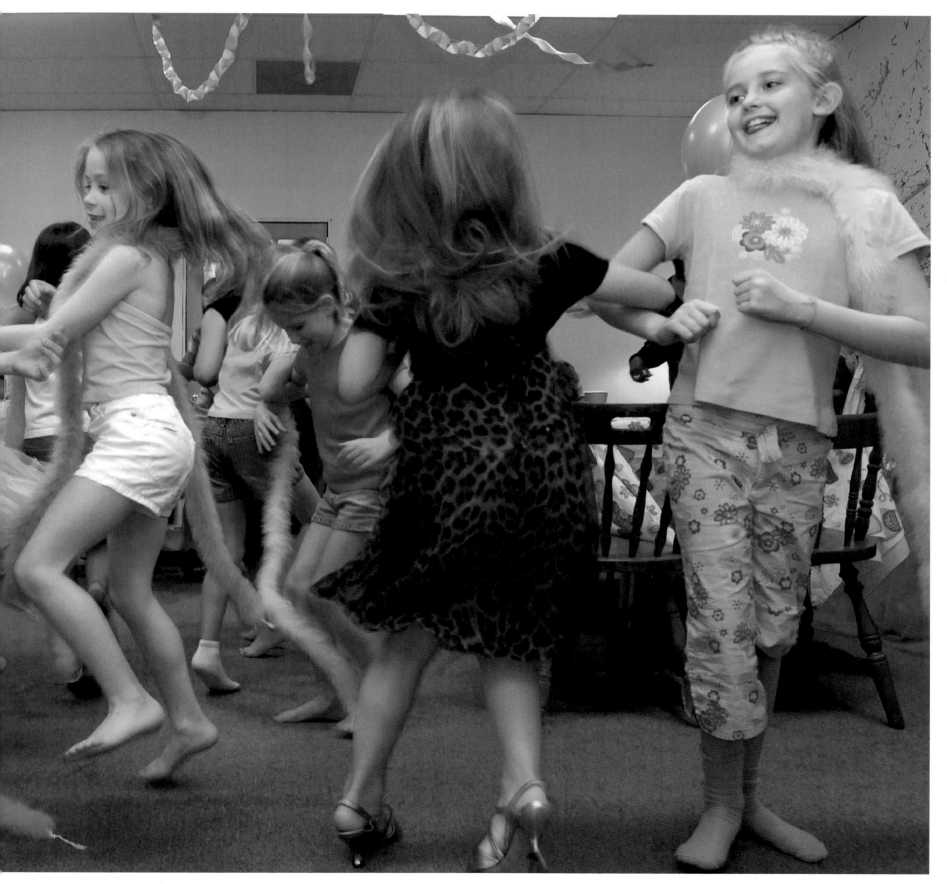

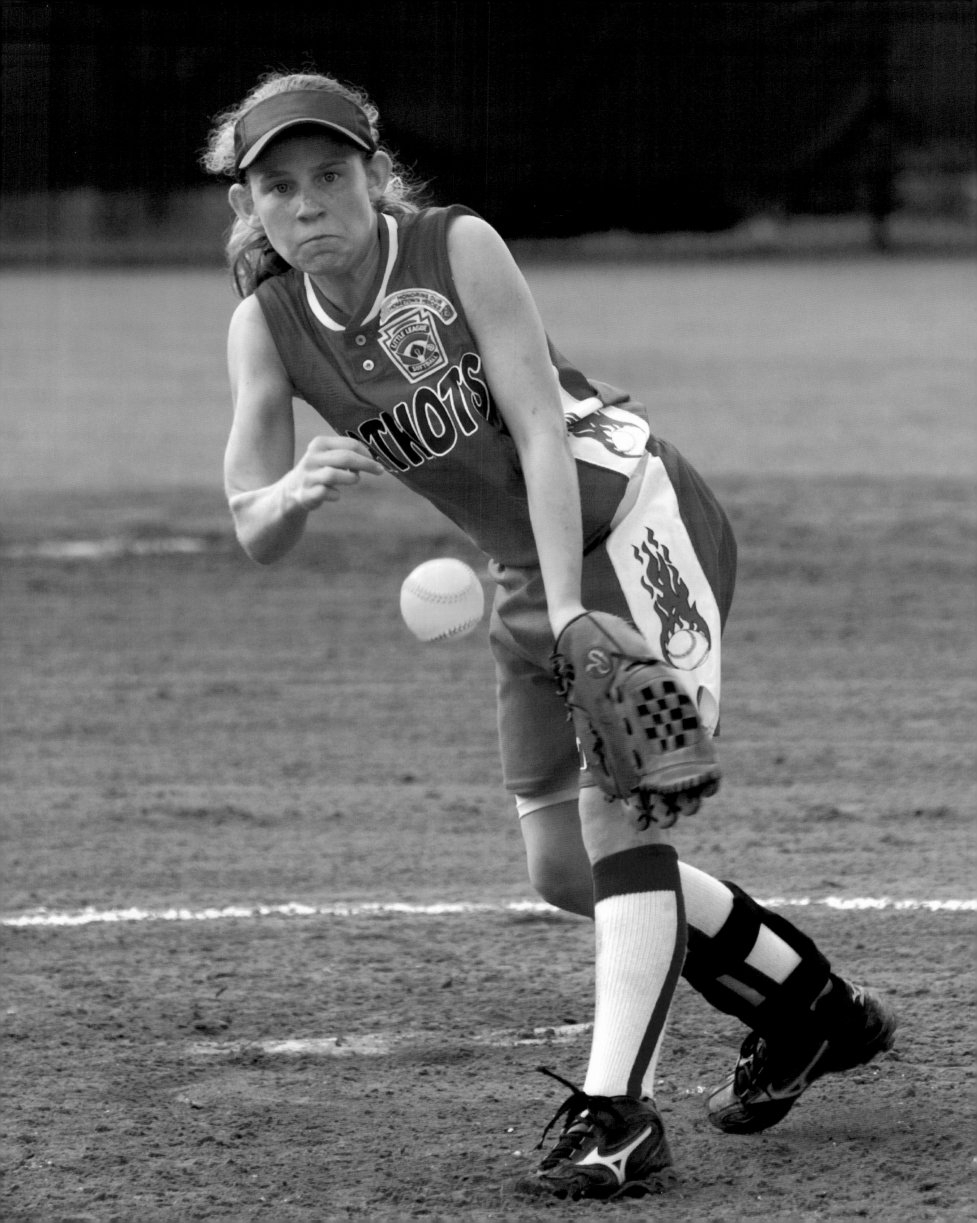

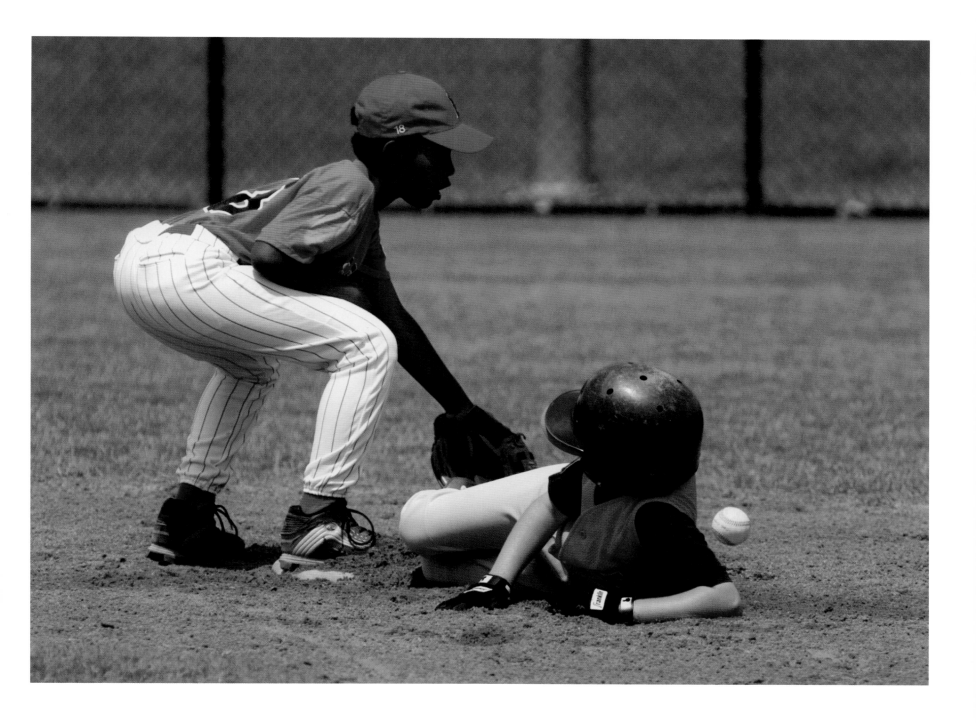

COLUMBUS

Columbus Patriots pitcher Megan Wilkinson is renowned for her deadly accurate fastballs and her on-field intensity. Off the pitcher's mound, she's a mild-mannered 12-year-old, says mom. But as soon as she puts on her glove, she gets her game face on.

Photos by Chip Griffin

COLUMBUS

Safe! An Orioles batter slides into second base just before Angels second baseman Justin Dixon fields a throw from the outfield.

The 1864 Battle of Resaca was the first major military encounter of the Civil War's Atlanta campaign. About 150,000 men fought in the battle. Now, Mary Elizabeth Murphy, perched next to her grandmother, Trisha Warren, gets to be part of a reenactment with her cap rifle. Reenactors take turns portraying Union and Confederate soldiers.
Photo by Laura Noel

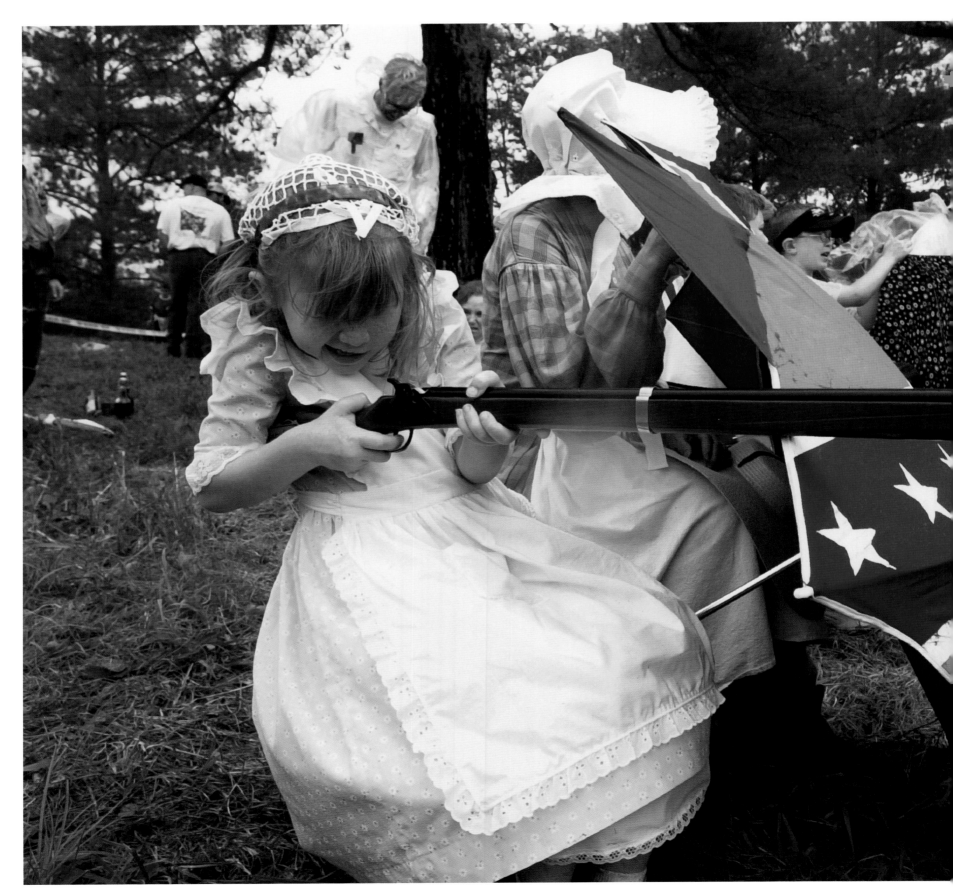

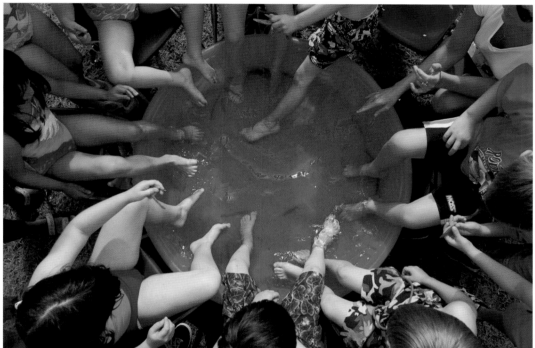

EVANS

A week before school ends, Riverside Elementary's kindergarten class got a little stir crazy. Students were too distracted to learn their ABCs, so their teacher let the 5-year-olds "toe fish" for plastic worms in the school's outdoor kiddy pool.
Photo by Rob Carr

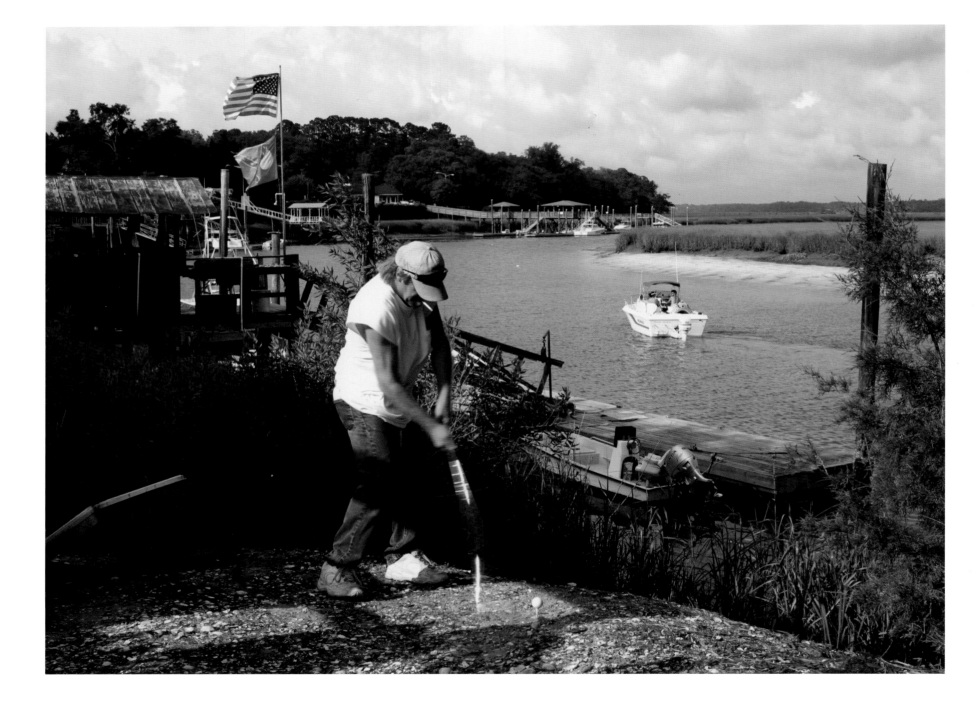

SHELLMAN BLUFF
When business is slow at the Shellman Fish Camp, a boat hoist and fishing supplies establishment, the half-dozen employees each throw a dollar in a pot and pull out their long irons. Whoever hits a golf ball across the creek closest to the target of the day wins the money.
Photo by Flip Chalfant

DECATUR

With visions of greatness, Derek Jamison, 5, of Clarkston practices his golf swing on the driving range at Hidden Valley Golf & Baseball Center.
Photo by Jamie Squire

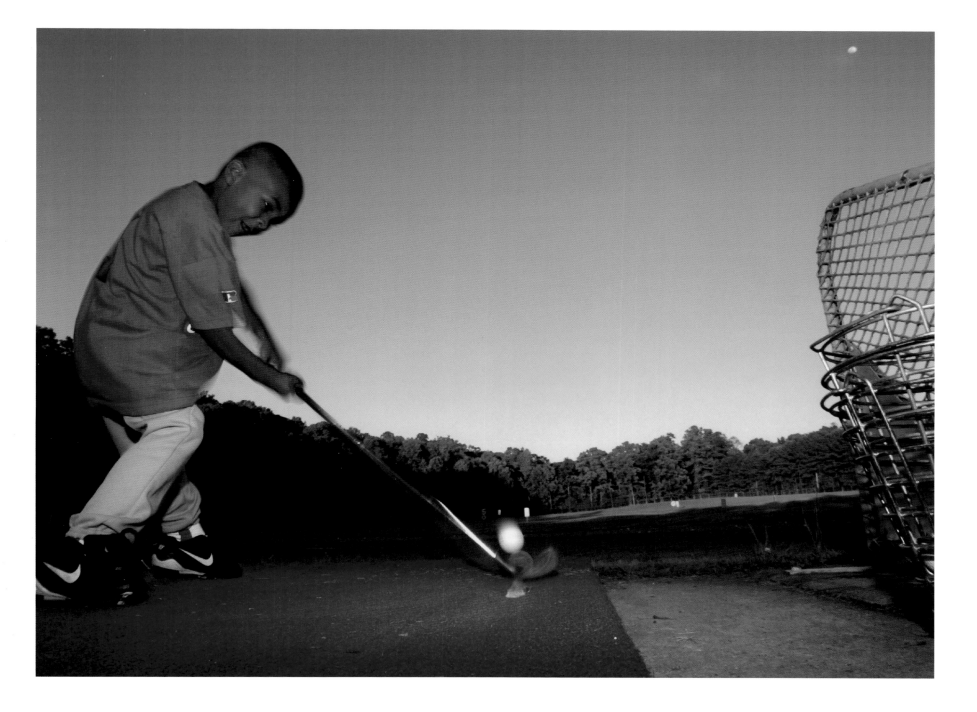

CRESCENT
Cali Chalfant watches mom Lane drop off her little sister, Lili, ashore at Crabman Beach, aka the Redneck Riviera. Accessible only by boat, the 40-yard-long, secluded strand on the Sapelo River is the Chalfants' favorite boating destination. In the distance are Sapelo Island, the Intracoastal Waterway, and Otis, the family dog.
Photo by Flip Chalfant

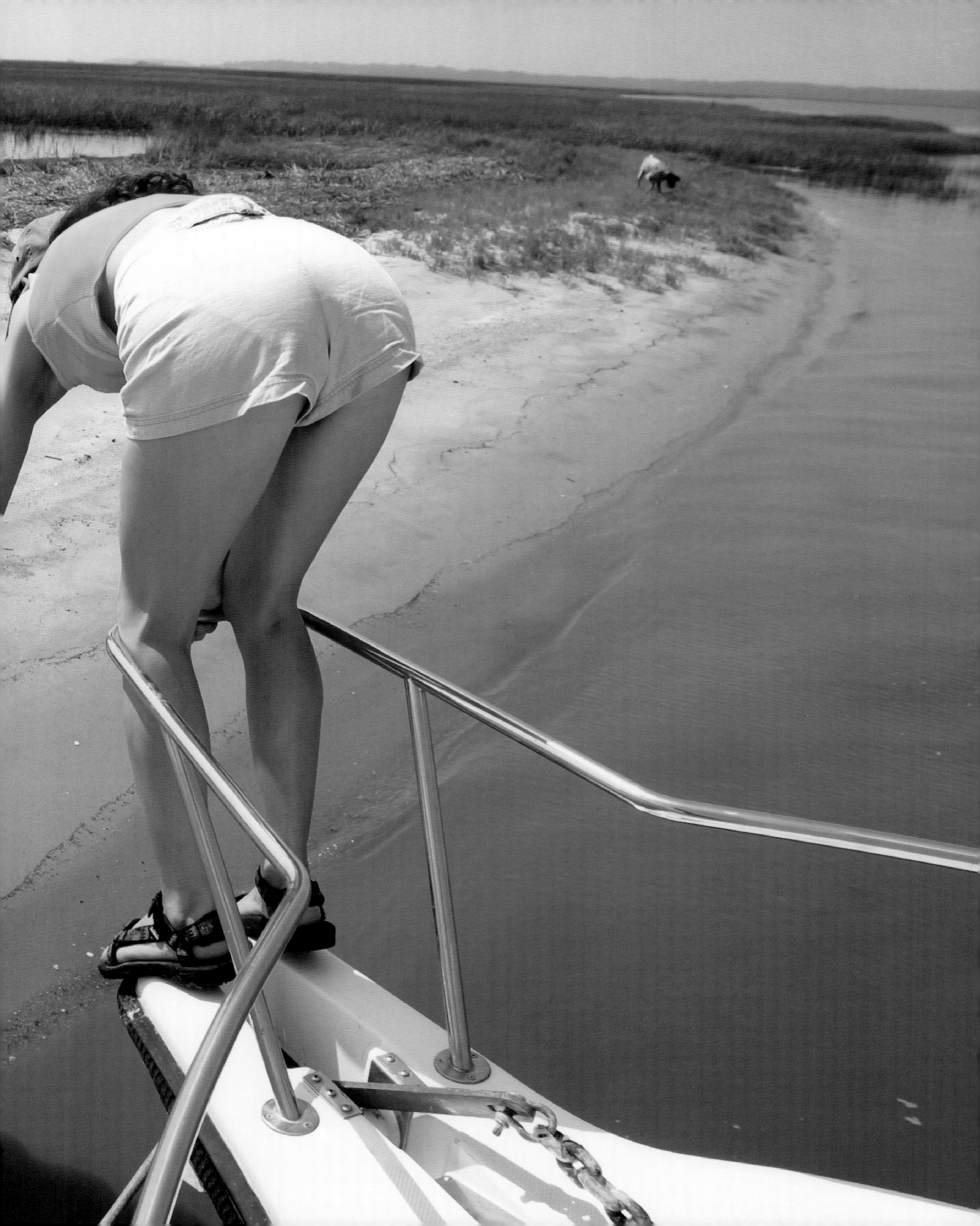

ALPHARETTA

Pastor Reggie Joiner preaches to the congregation at Evangelical Northpoint Community Church. Founded in 1995, the church has 3,000 members and reaches out to kids, high school students, and single adults. Those outside the faith are thought to be living in "the lost world."

Photo by Rachel LaCour Niesen

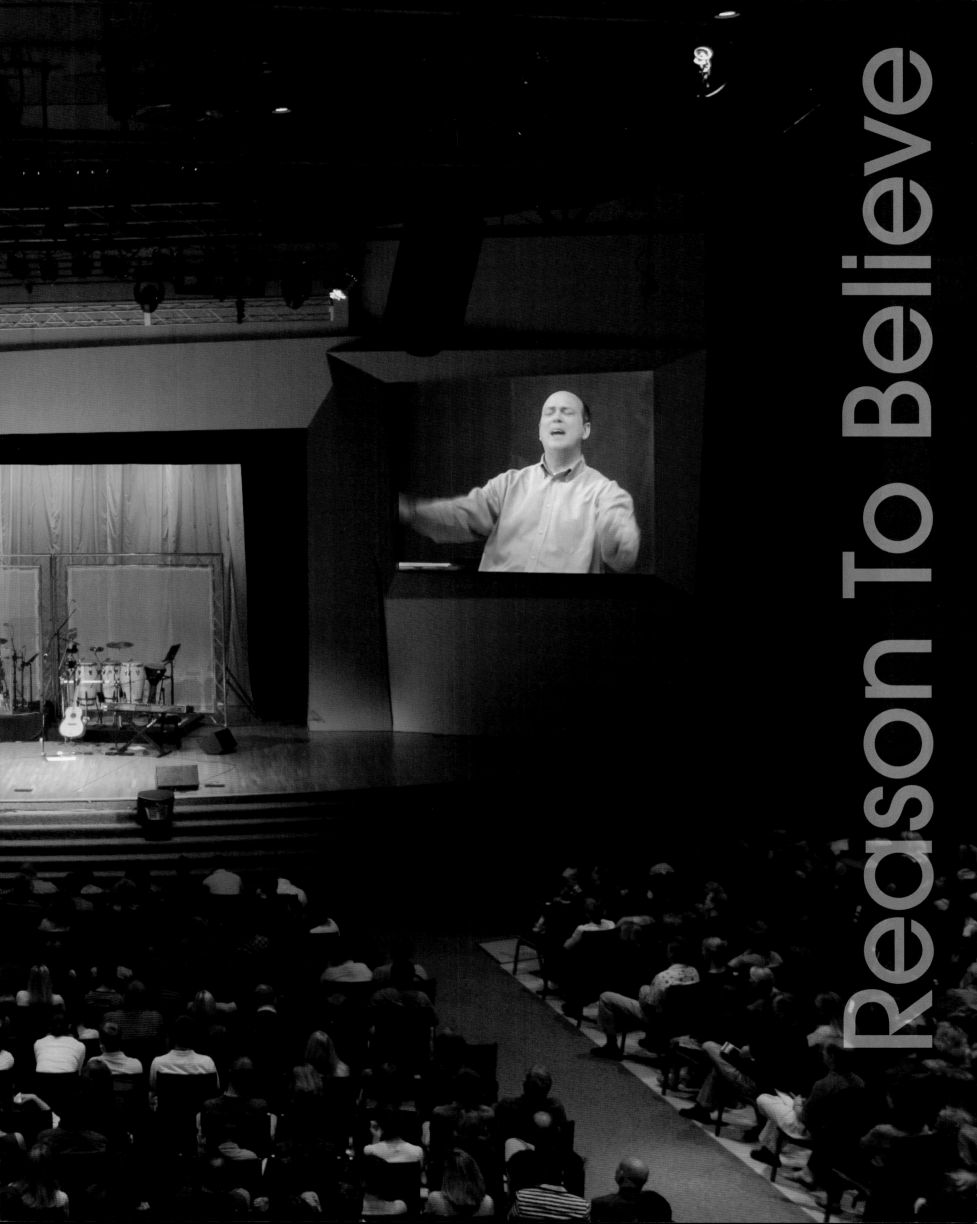

Reason To Believe

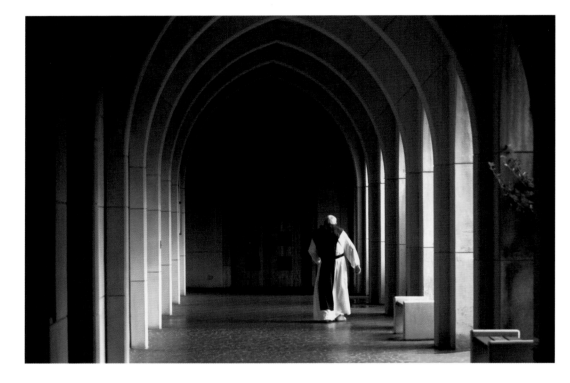

CONYERS

A monk passes through a cloister of the Monastery of the Holy Spirit, a Trappist abbey built when the Our Lady of Gethsemani monastery in rural Kentucky had a surge in vocations and needed to expand. At the invitation of Bishop Gerald O'Hara, head of the Savannah-Atlanta diocese, the order dedicated Holy Spirit in 1944.
Photos by Curtis Compton

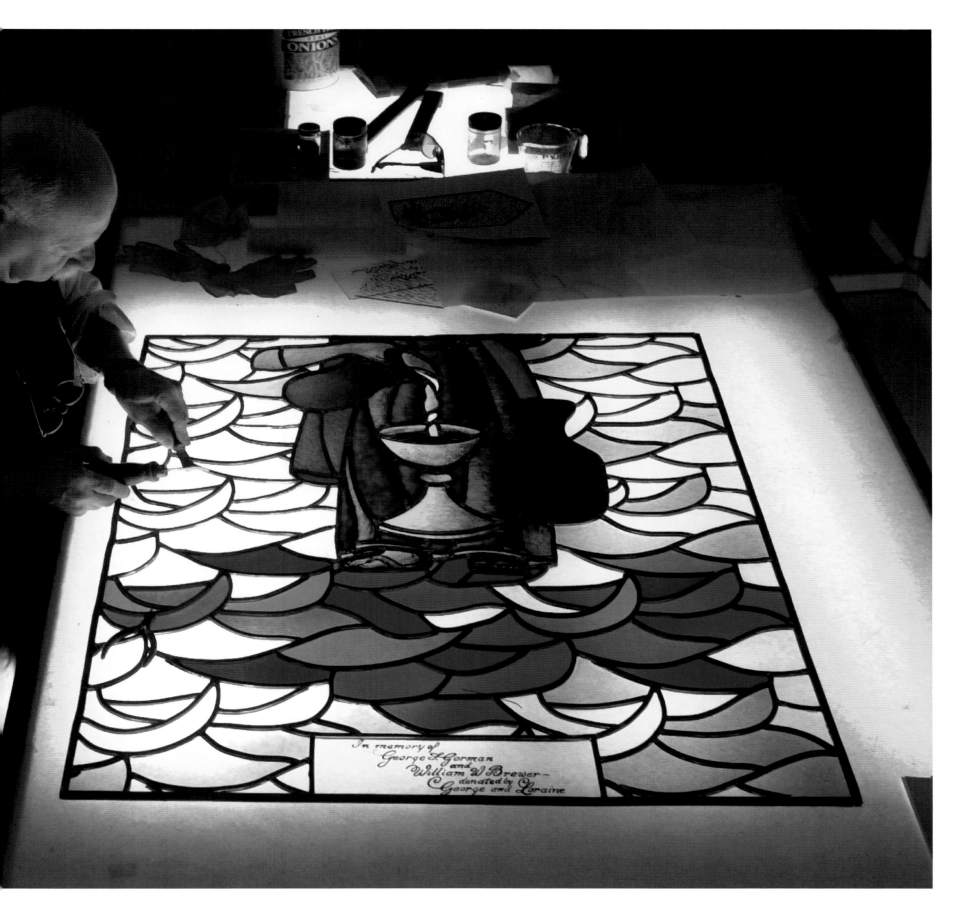

CONYERS

In 1957, a young Father Methodius Telnack taught himself to make stained glass windows, and he's been at it ever since. "I just took some books out of the library and got started," says the Trappist priest. He creates his own designs—and sales from the windows help support the monastery where he's a resident.

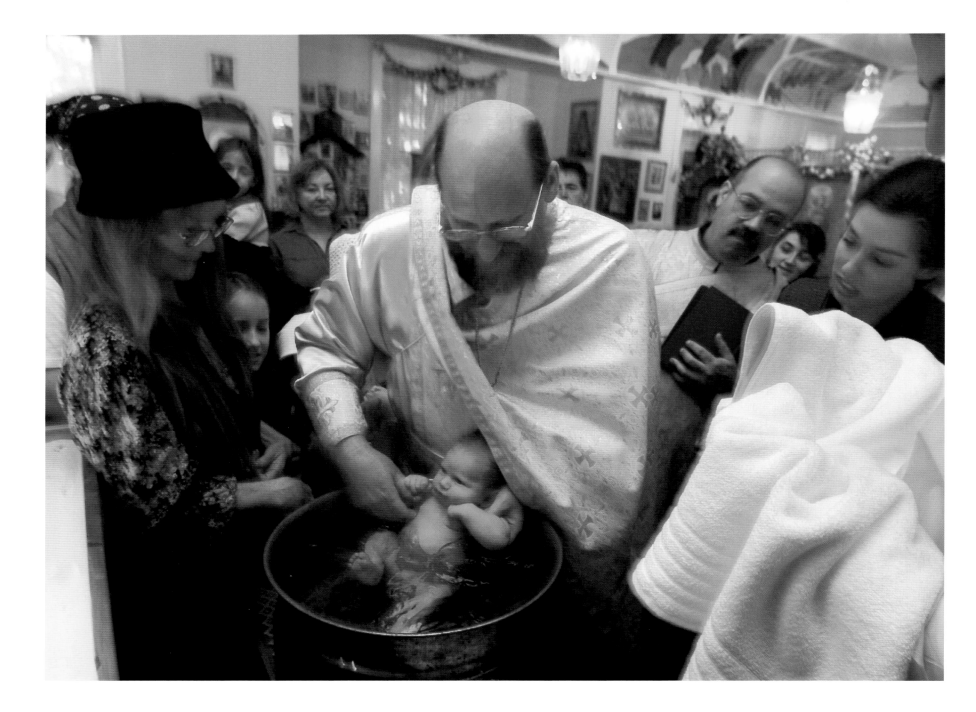

ATLANTA

Father Jacob Myers baptizes newborn Luke Avaliani during Sunday morning service at St. John the Wonderworker Orthodox Church. The parish is the first in the world named for St. John Maximovitch of San Francisco and Shanghai, who was canonized in 1994, 28 years after his death. The Eastern Orthodox missionary was an ascetic known as a loving father of orphans.

Photos by Steven Schaefer

Maria and John Juskiewicz dated for 20 years be-
fore finally deciding to tie the knot. Minutes after
the ceremony, Father Myers leads the couple
from the church. The best man holds ceremonial
gold crowns over the bride and groom during
their procession.

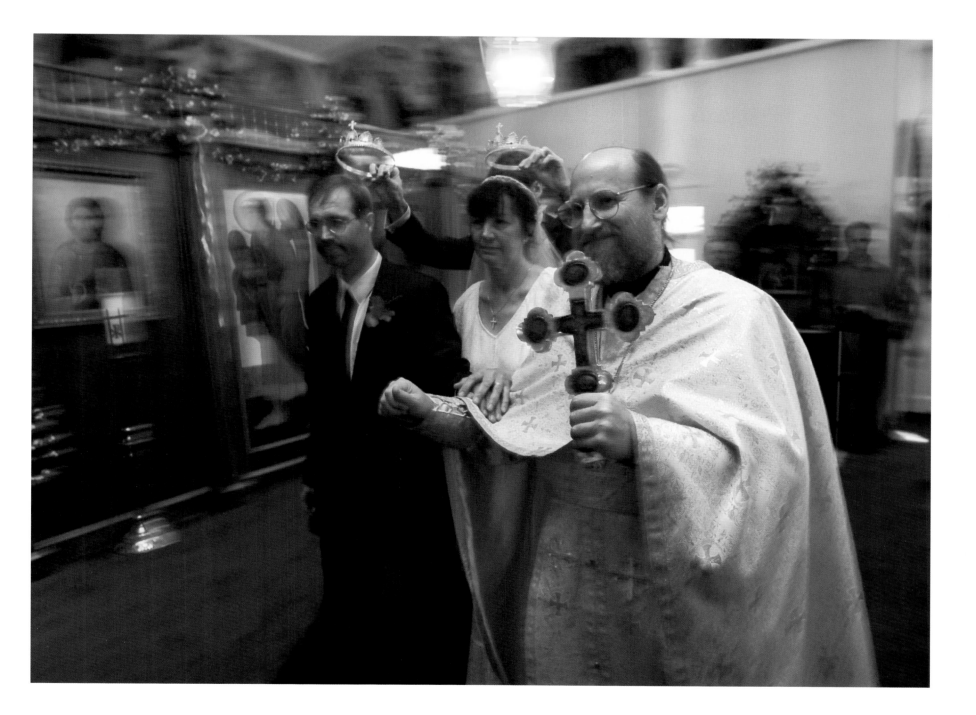

DORAVILLE

Reverend Chin Chen Kao reads the Chinese characters of a Buddhist Sutra text. The Taiwan native holds a weekly study group in his suburban Atlanta home where he helps adherents interpret the Buddhist scripture. He draws his students from Atlanta's growing Mandarin-speaking community.
Photo by Sunny H. Sung,
The Atlanta Journal-Constitution

KINGSTON

A passage in St. Mark's gospel that "they shall take up serpents and if they drink any deadly thing, it shall not hurt them" convinced Reverend Junior McCormick to handle copperheads and rattlesnakes during sermons at the Church of the Lord Jesus Christ. McCormick also drinks strychnine-laced water, which, he says, "makes you feel like your mind's dripping out of your head."
Photo by Tami Chappell

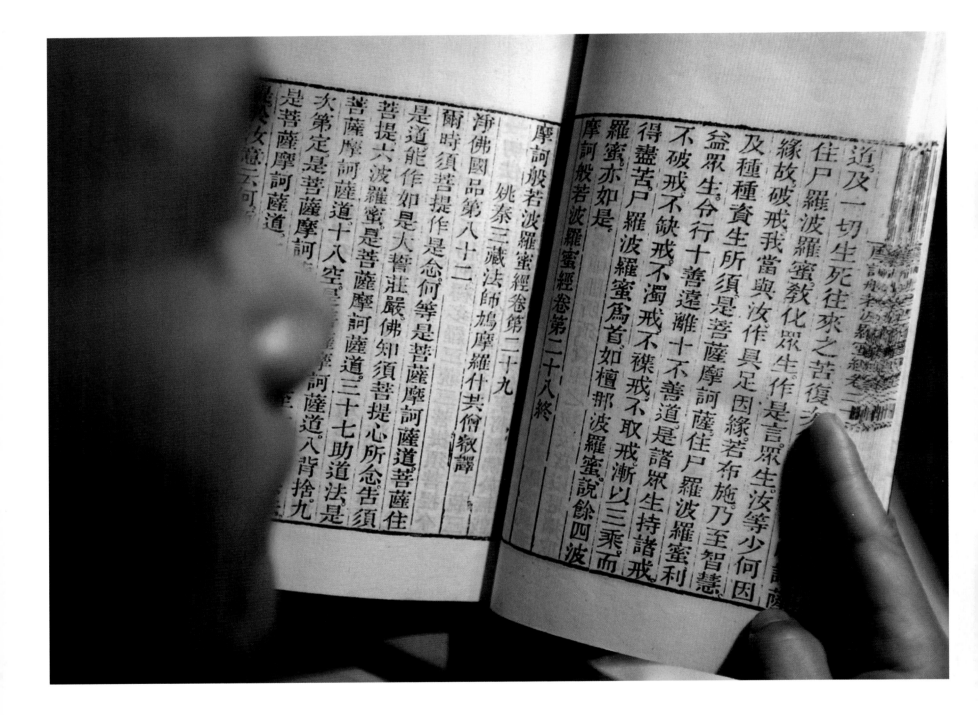

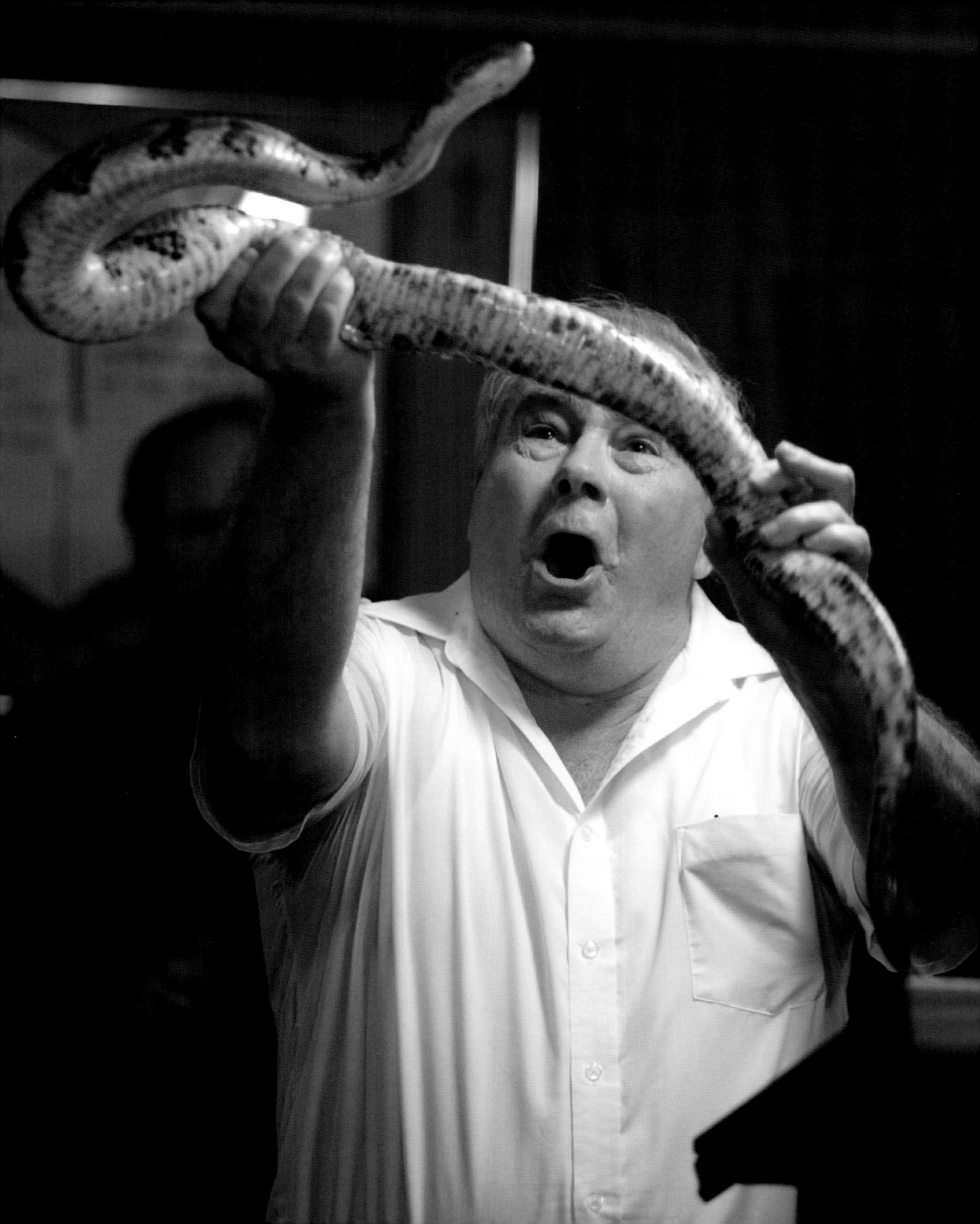

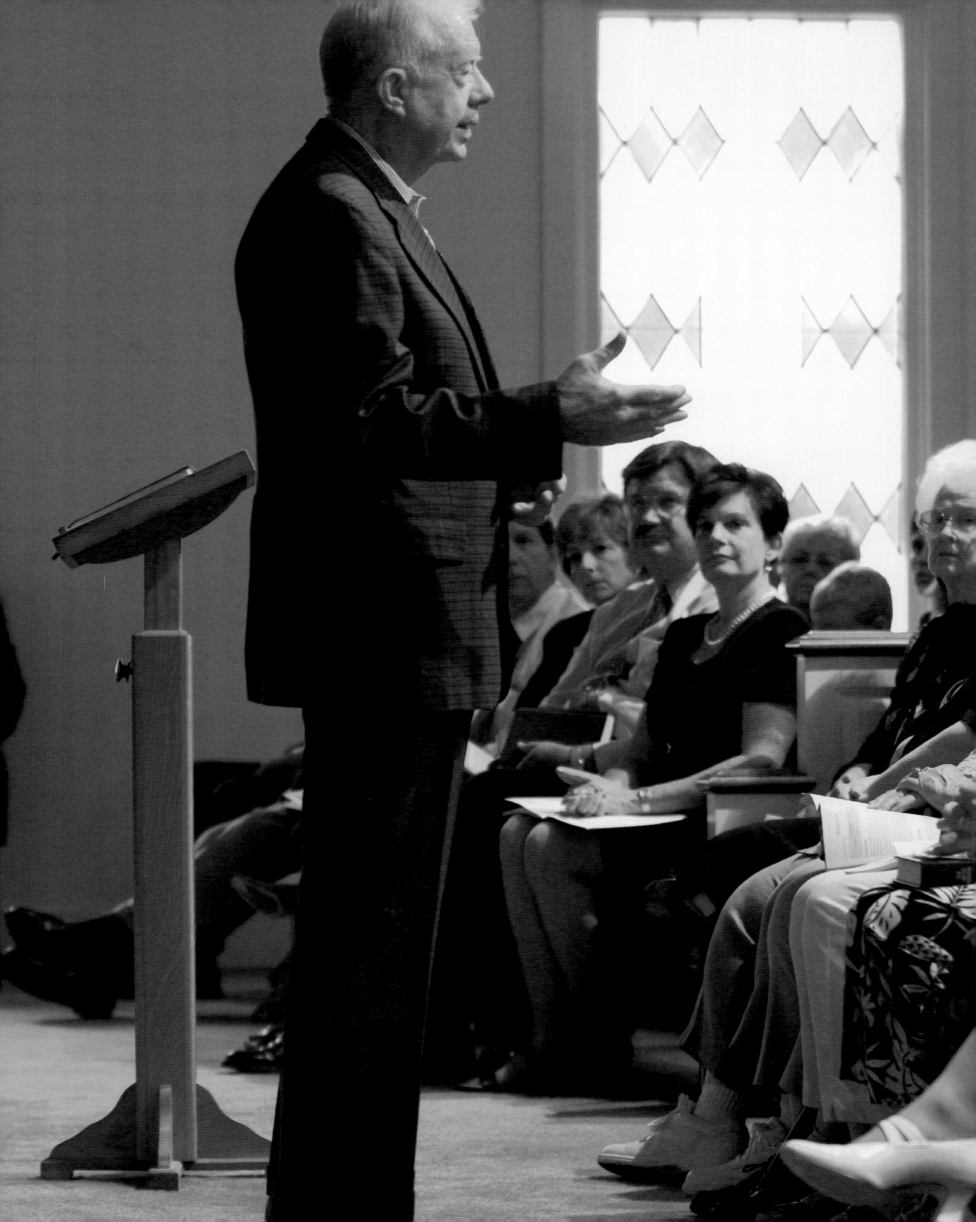

PLAINS

Former President and Nobel Peace Prize winner Jimmy Carter gives one of his popular Sunday sermons to an SRO crowd at Maranatha Baptist Church. Since leaving the White House in 1980, Carter has devoted his energy to eliminating poverty and fostering democracy in the Third World. In between trips abroad, he still makes time for preaching at his hometown church.

Photo by Joey Ivansco

ATLANTA

Cantor Nestor Muhlfelder recites a prayer to begin Sunday morning service at St. John the Wonderworker Orthodox Church. Named for St. John Maximovitch, the church has collected several items of the saint's apparel and a bone relic from his foot.

Photo by Steven Schaefer

BISHOP
Verner Hammond and wife Mildred have run a produce stand for 23 years, and they pray for almost every customer. "I run hog-wild until I was 56, then one day I got tired of that life," says 77-year-old Hammond. "Now the local preacher wants a fruit stand 'cause I do more praying on people than he does."
Photo by Karekin Goekjian

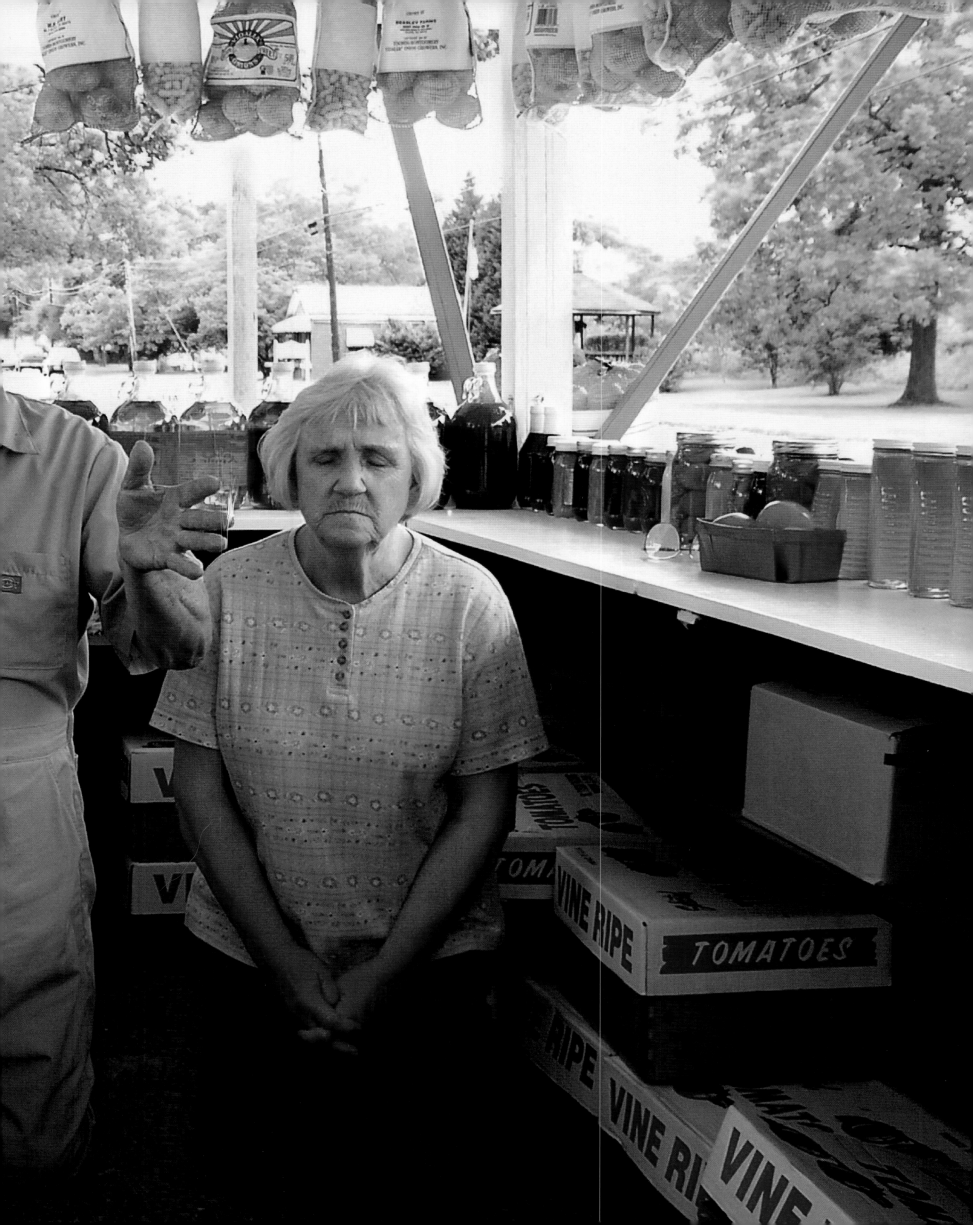

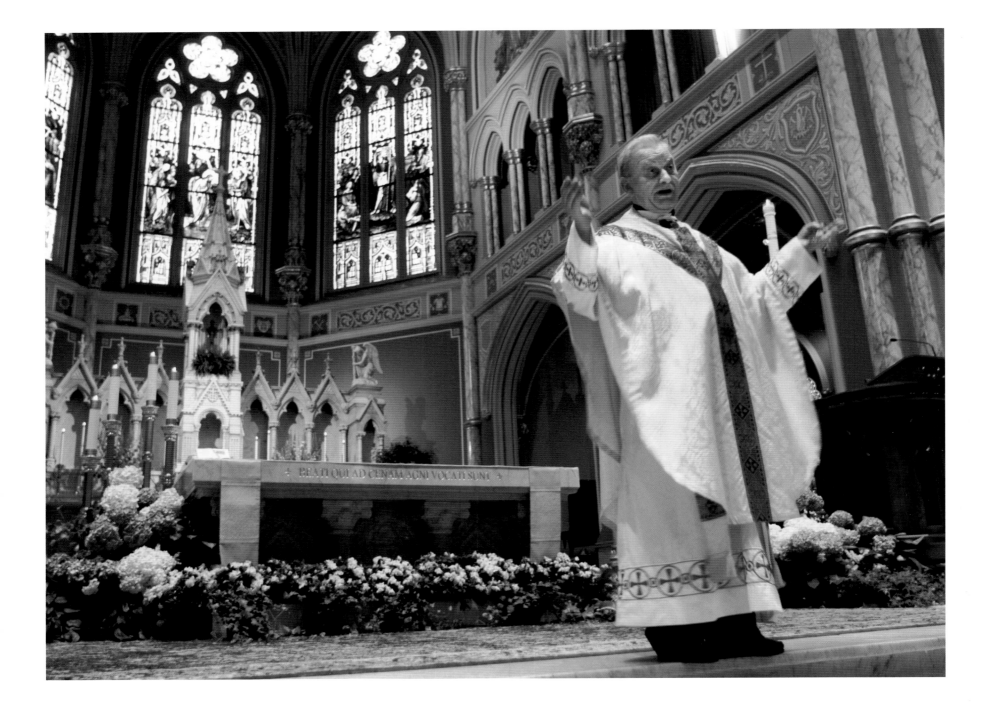

SAVANNAH

The oldest Roman Catholic church in Georgia, the Cathedral of Saint John the Baptist on Lafayette Square was dedicated in 1876. Reverend Monsignor William O'Neill celebrates mass at the French Gothic cathedral designed by Francis Baldwin. Established by French Catholics, the church is richly appointed with Italian marble, Austrian stained glass, and Persian rugs.

Photo by Stephen Morton, stephenmorton.com

DILLARD

Artist Eric Legge doesn't title the eclectic art he makes from plywood, paint, canvas, tin, glass, bottle caps, and scrap metal. In a newspaper interview, Legge explained that, "Sometimes when people look at a painting, they see something I didn't know was there. If I put a label on it, they might not see their version."
Photo by Gene Driskell

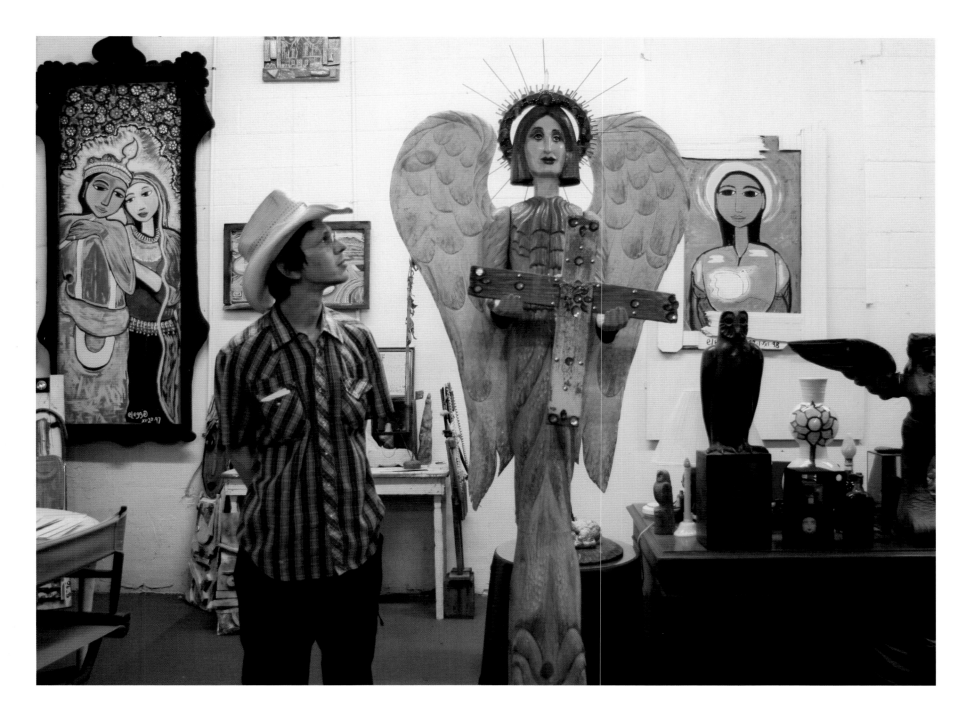

ANDERSONVILLE
During the last 14 months of the Civil War, the notorious Andersonville prison at Camp Sumter confined more than 45,000 Union soldiers. Here, Dan Gardner, Douglas Lake, and Sandra Gardner visit the National Historical Site—and the graves of some of the 13,000 prisoners who died of disease, exposure, and malnutrition.
Photo by Steven Schaefer

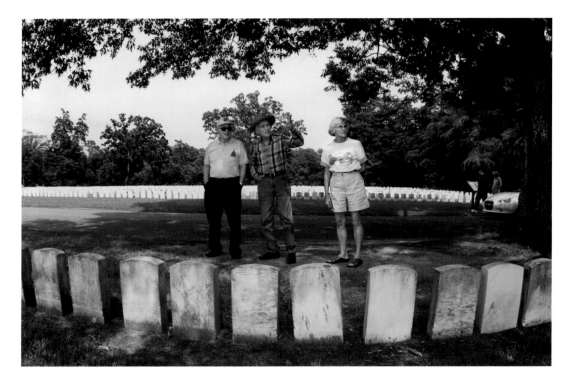

ATLANTA

A reflecting pool the length of a football field surrounds Martin Luther King, Jr.'s tomb at The King Center in the Sweet Auburn district. Custodian Bobby Blalock spends his mornings cleaning coins off of the tomb's surface—that is, when the neighborhood's homeless don't collect them first.

Photo by Joey Ivansco

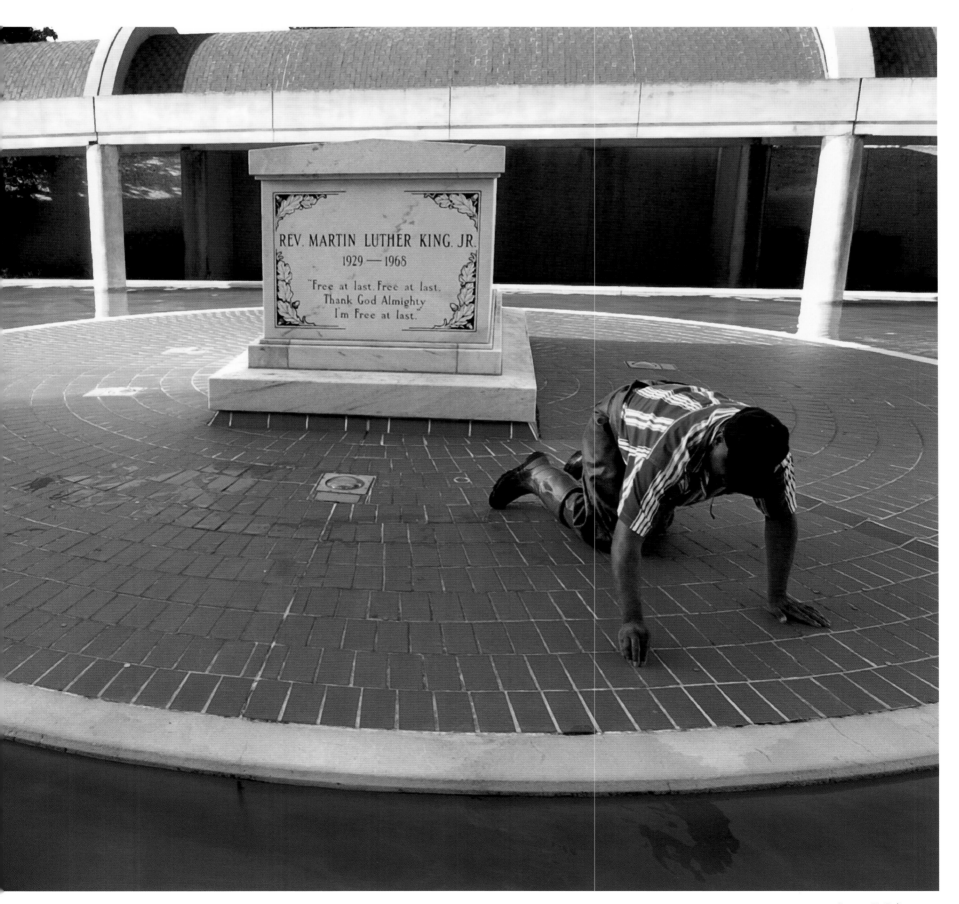

WAYNESBORO
Before recent public land reclassifications in southern Georgia made some counties bigger, Waynesboroans liked to refer to their town (pop. 6,000) as the "biggest city in the biggest county in the biggest state east of the Mississippi."
Photo by Jonathan Ernst

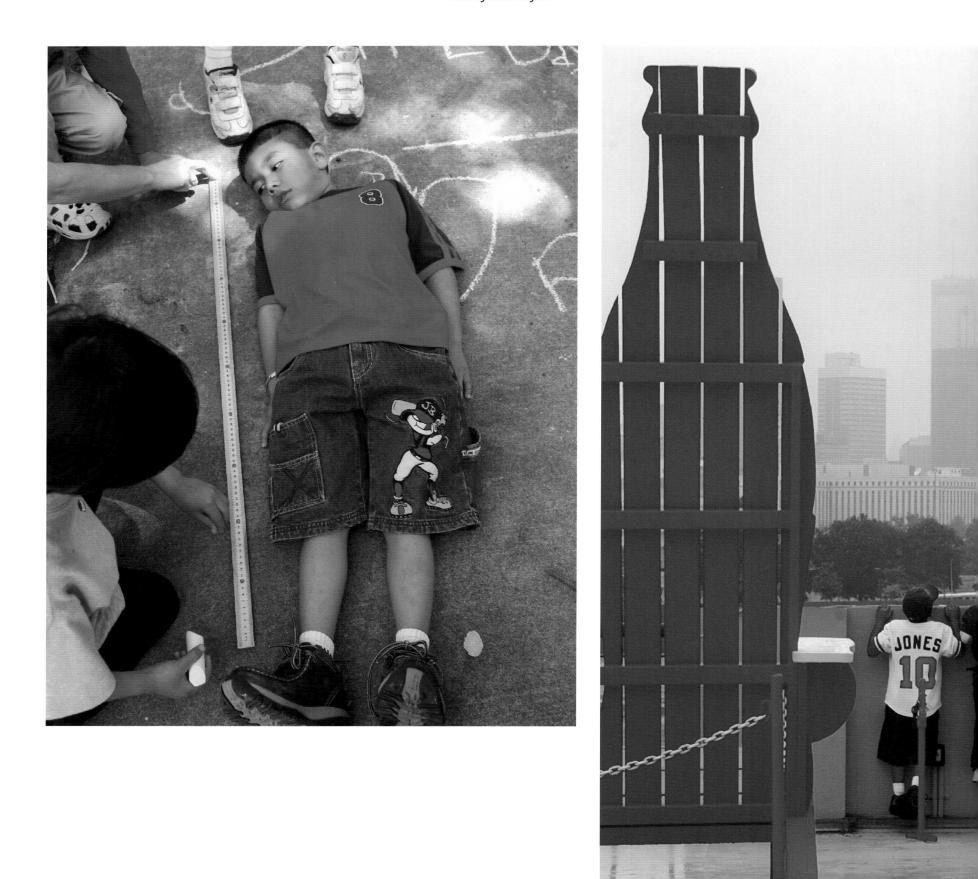

ATLANTA

How many 5-year-olds does it take to make one diplodochus? About 30. Classmates measure Miguel Heredia, Jr. as part of a project that teaches spatial concepts to kindergarteners at Garden Hills Elementary School. Students take turns measuring each other to see how many of them it takes to reach the 90-foot length of the long-necked, whip-tailed dinosaur.

Photo by Jean Shifrin

ATLANTA

As part of its sponsorship contract with the Atlanta Braves, the Coca-Cola Company carved out some hometown advertising with these over-sized nosebleed seats high above Turner Field's outfield. Pint-sized Buford Elementary School kids needed a boost to try 'em out and to get a peek at the downtown Atlanta skyline.

Photo by Rich Addicks,
The Atlanta Journal-Constitution

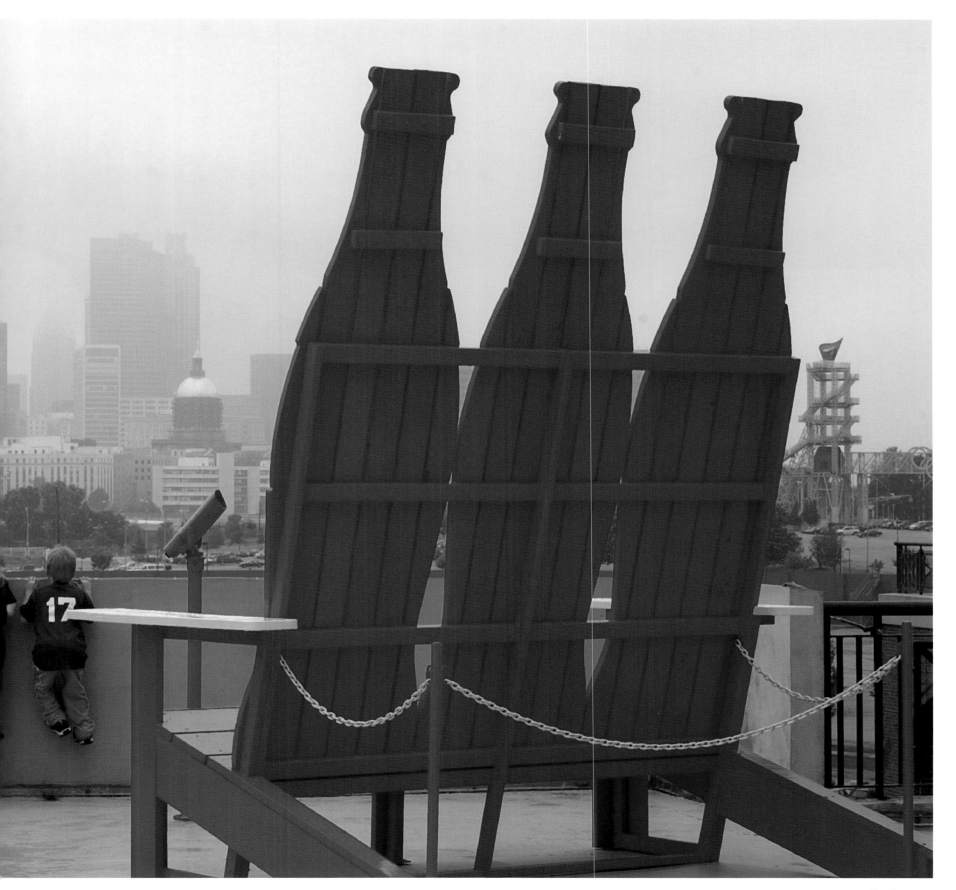

IN MEMORY OF
THE 400+ GALLANT
MADISON COUNTY
CONFEDERATES WHO
SACRIFICED SO MUCH FOR
SOUTHERN INDEPENDENCE

COMPANY "A"
16TH GEORGIA
VOLUNTEER INFANTRY
THE MADISON COUNTY GREYS
159 MEMBERS

COMER
A Confederate memorial honoring the 16th
Georgia Volunteer Infantry sits in a small
park in the center of Comer. The men, nick-
named "Ramsey Vols," were among the
14,000 Confederate defenders who fought
in vain to halt U.S. General William Tecumseh
Sherman's devastating March to the Sea,
from Atlanta to Savannah, in 1864.
Photos by Phillip G. Harbin, Jr.

ATLANTA

Hammerin' Hank: The bronze statue of Hank Aaron outside the north entrance to Turner Field shows the slugger hitting his 715th home run on April 8, 1974, which broke Babe Ruth's record. Before he retired in 1976, Aaron went on to hit forty more homers for a standing major league career record of 755.

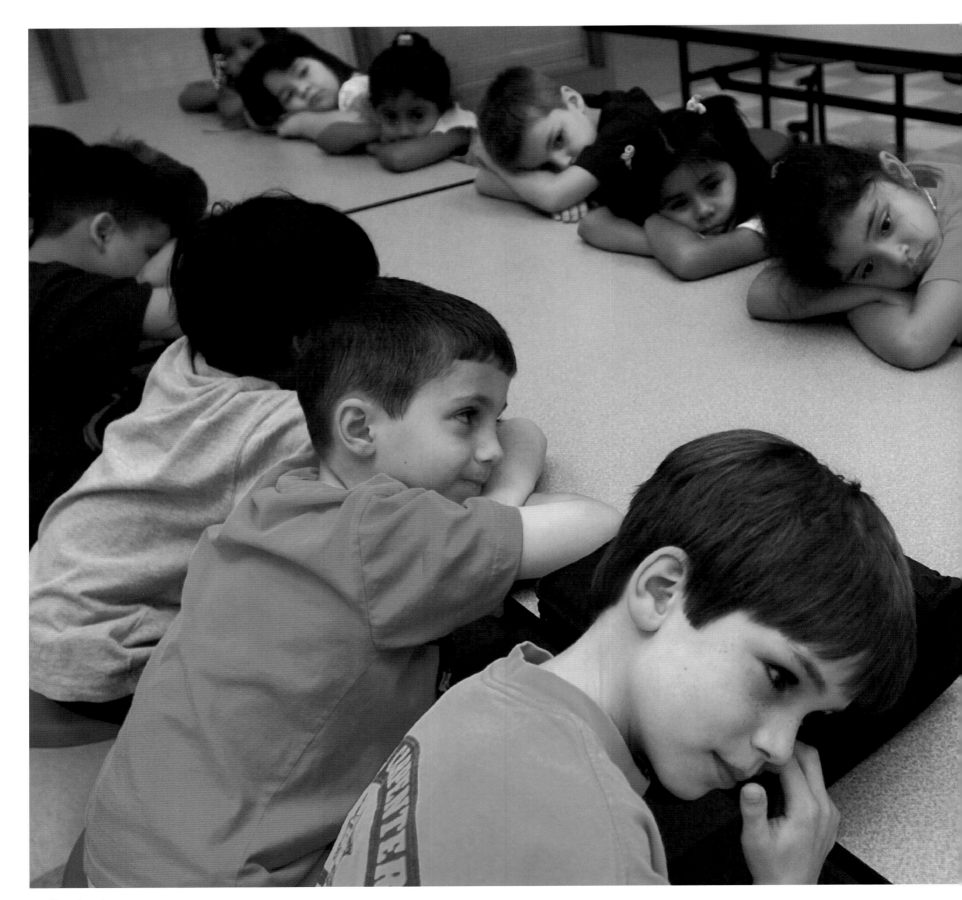

ATLANTA

Garden Hills Elementary has 460 students and a student-teacher ratio of 8 to one. More than half of Fernando Rumualdo's classmates come from homes where English is a second language. For 40 years, the school has had students from 100 countries and five continents.

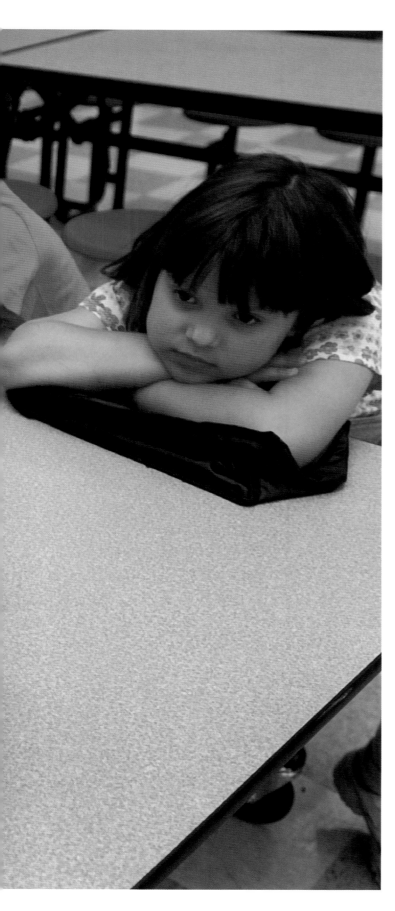

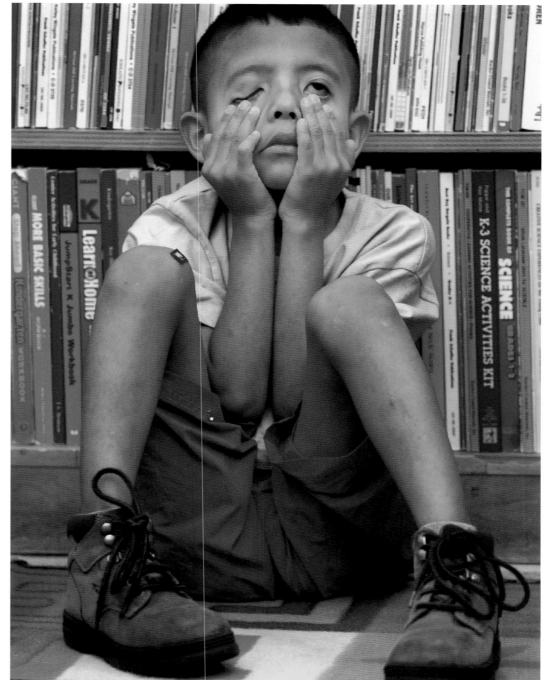

DORAVILLE
Joanne Liew plucks the 25 strings of a Guzheng, a horizontal harp, as she applies pressure with her left hand to create vibrato and glissando effects. The classical Chinese instrument has a three-octave range and produces an ethereal, melodic sound.
Photo by Sunny H. Sung,
The Atlanta Journal-Constitution

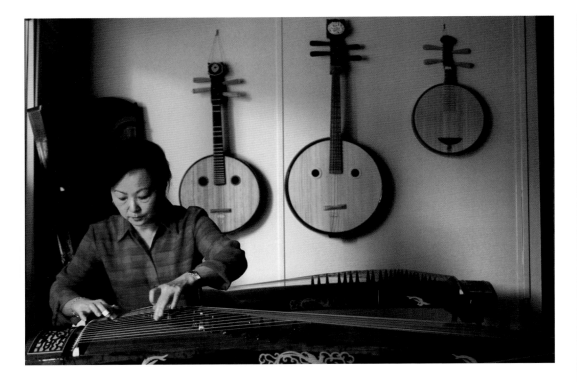

SUWANEE

The only rule at the Everetts is no alcohol. Every Saturday night, musicians from all over come to play bluegrass in the family's big barn. "It often doesn't stop until 5 or 6 in the morning," says Richard Burch, on guitar. The sessions outgrew the Everett's living room a while back, so the family built the barn with church pews that can hold 170 pickers, fiddlers, and fans.
Photo by Steven Schaefer

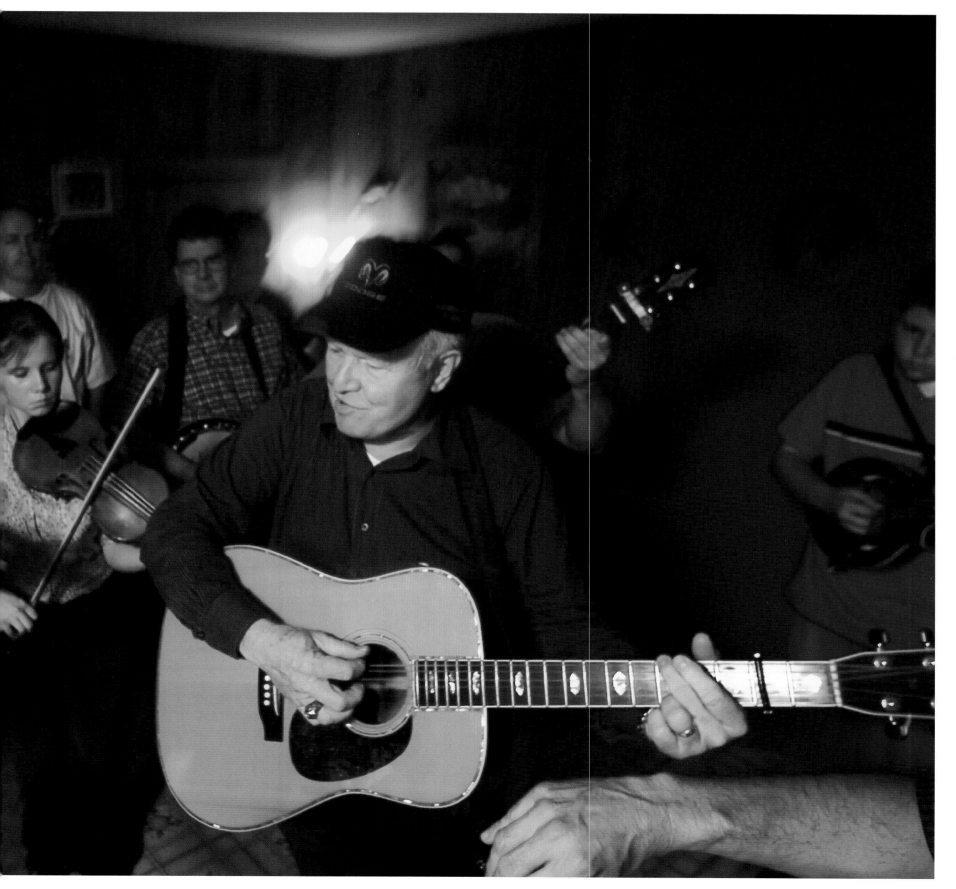

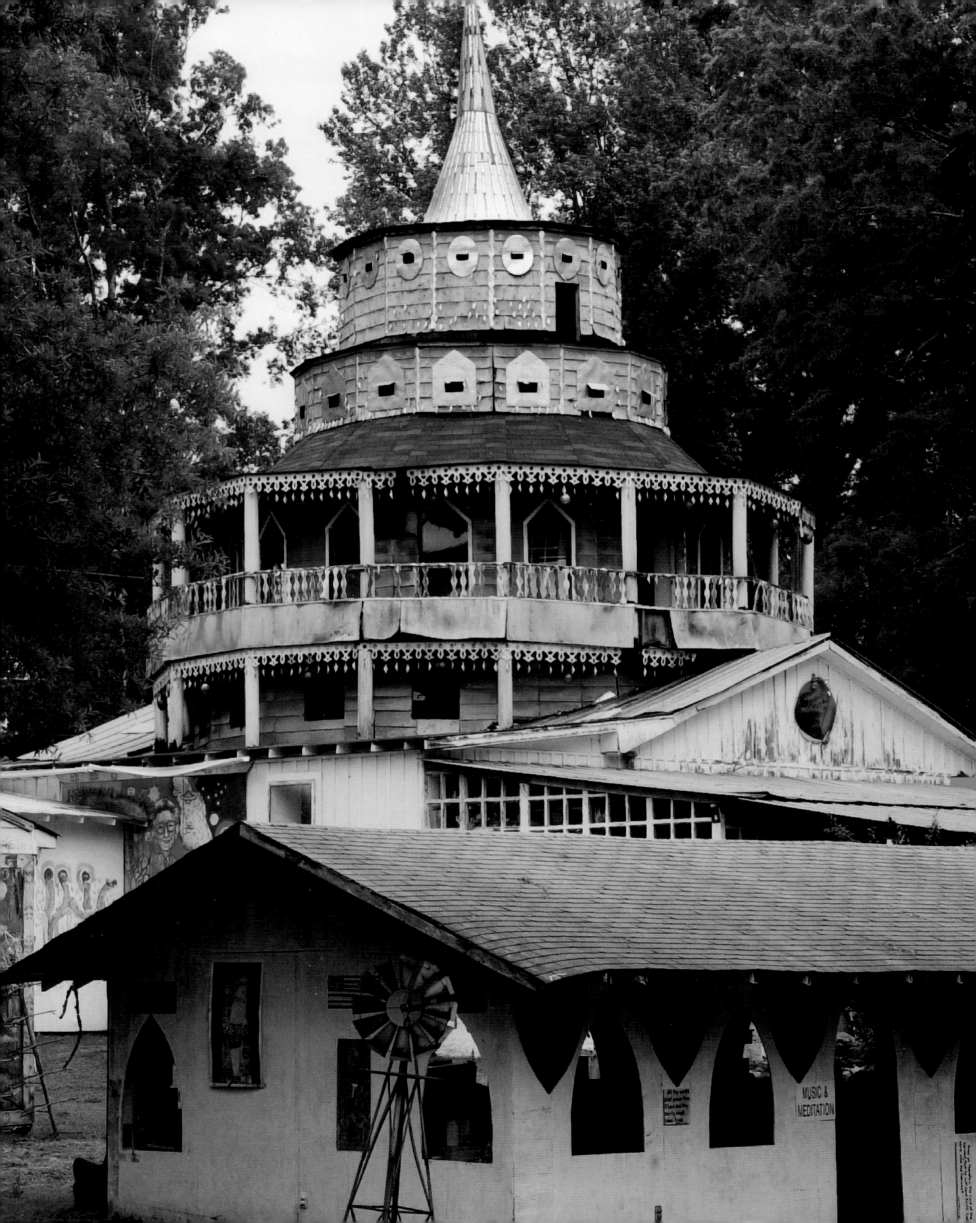

PENNVILLE

The late folk artist Howard Finster had a penchant for embellishing everything around him. The elaborate constructions at Paradise Gardens, his compound in the swamplands outside Pennville, were done to attract attention to the gospel of Christ. The artist even drew album covers for the Talking Heads and R.E.M., claiming the rockers were his missionaries.
Photos by Laura Noel

PENNVILLE

Sculptural monuments and found-object assemblages populate every shady nook at Howard Finster's place. Beneath loblolly pines and fruit trees, streams of channeled swamp water flow through the labyrinthine sculpture garden, with its inlaid concrete paths and hand-painted signs.

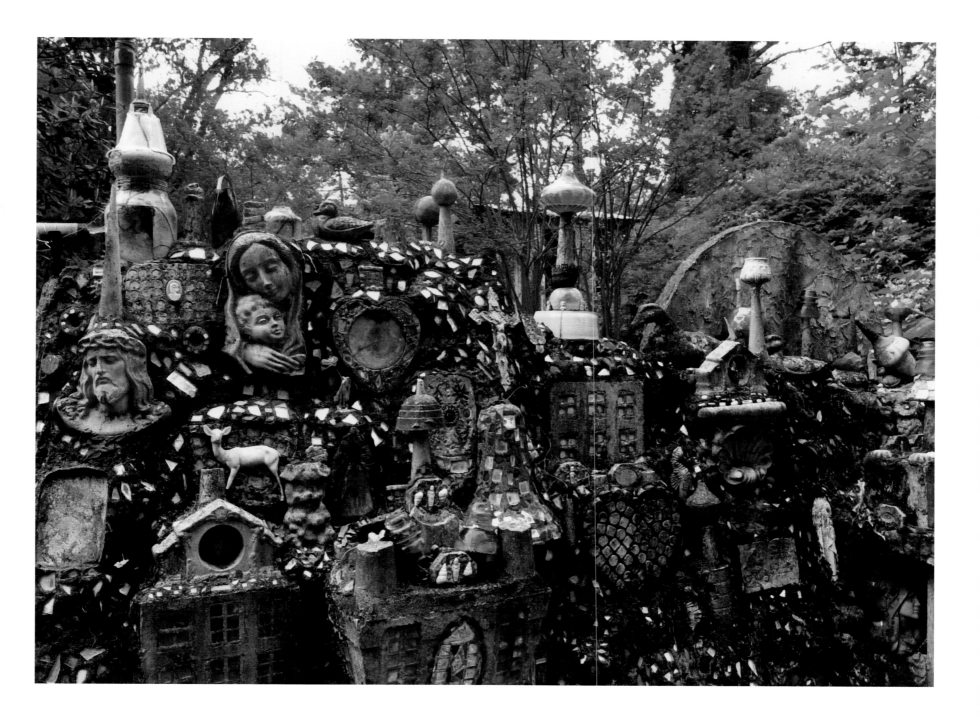

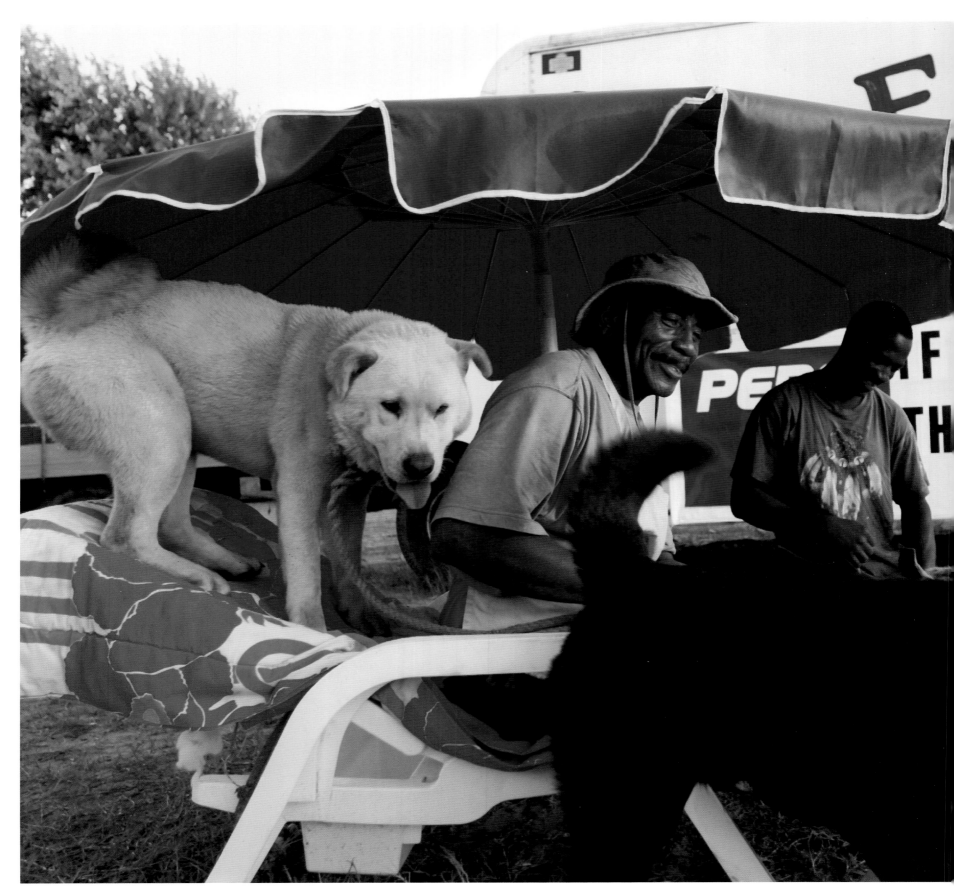

EULONIA

Almost every day, Raymond Wilson, along with his dogs Duffy and Ruffy, sets up at the intersection of highways 17 and 99 and sells fresh shrimp. The decorated Vietnam vet buys from local shrimpers and uses a very direct sales pitch to move the product.

Photo by Flip Chalfant

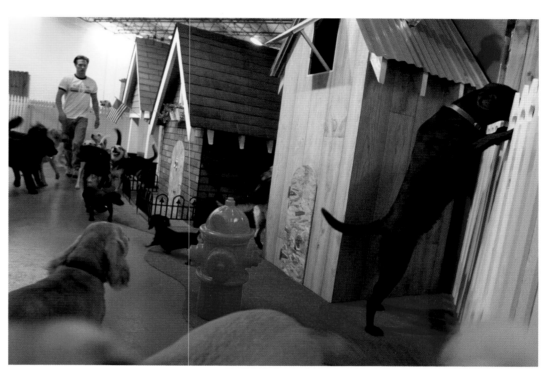

DECATUR

Daytime wards pad past doggietown, a canine-scale village at the Wag-A-Lot kennel and day care. Eighty dogs—from schnauzers to pit bulls—spend their days frolicking around the 10,000-square-foot facility. Four live webcams stationed throughout the canine playground enable clients (who pay $87/week) to check up on their pets online.

Photo by Joey Ivansco

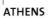

ATHENS

Seventy-five years ago, Frank Gordy opened the first Varsity Drive-in near Atlanta's Georgia Tech. Since then, the chain has grown to seven restaurants including the Athens Varsity. In addition to being a stickler for quality ingredients, Gordy pioneered curb service in Georgia.
Photo by Karekin Goekjian

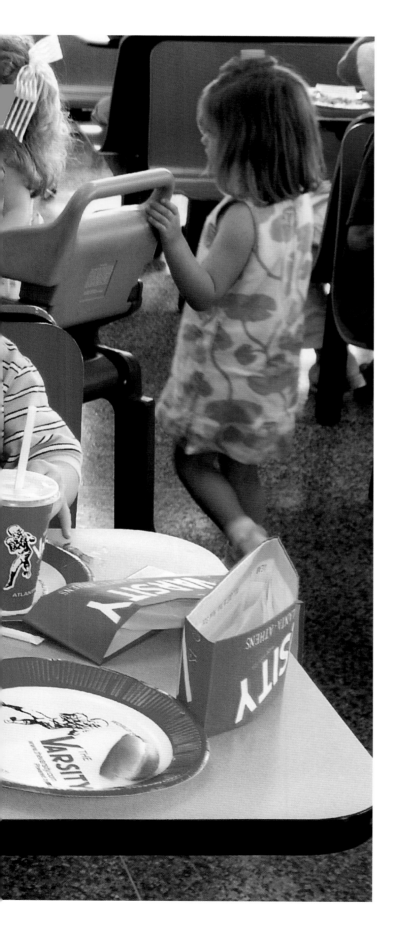

JACKSON

John Kemnitzer checks the hams in the pit at Fresh Air Bar-B-Que. When the joint first opened in 1929, it was just an open pit with no roof. Since then, the building's been improved but the menu has stayed the same: barbecue pork, Brunswick stew, and coleslaw. In 1984, it was voted "best barbecue in Georgia."
Photo by Ben Gray

DOBOY SOUND

Roe shrimp are a tasty specialty of the Georgia coast. But they're not commanding the prices they once did, and local shrimpers are feeling the pinch. Farmed shrimp imported from China, Vietnam, Thailand, India, Brazil, and Ecuador have caused prices to plummet. In response, fishermen from eight southeastern states have filed suit against the countries.
Photo by Flip Chalfant

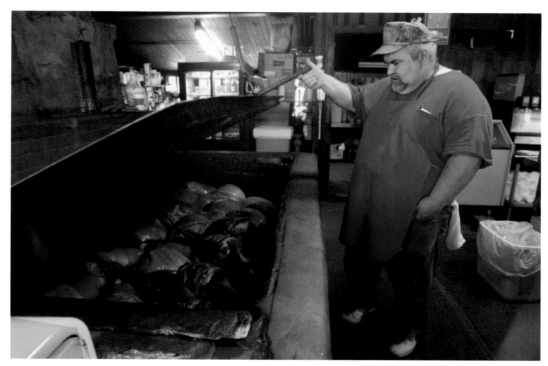

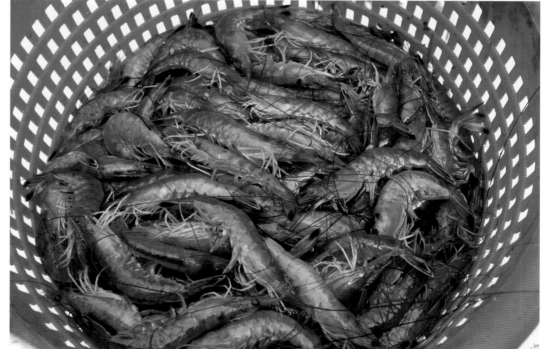

ATLANTA

Star linebacker John Grant wants to go pro after graduating from Morehouse College, an all-male, African-American school founded in 1867. Its most famous alumnus, Dr. Martin Luther King, Jr., was an ordinary student until he met Professor Walter R. Chivers, a sociologist and outspoken critic of segregation who wrote articles about the role of black leaders in the struggle against oppression.
Photos by Joey Ivansco

ATLANTA
Emory University law school graduates face an uncertain future—the economic recovery continues and legal jobs are scarce. Melissa Klein keeps things light and bubbly with a midceremony flourish.

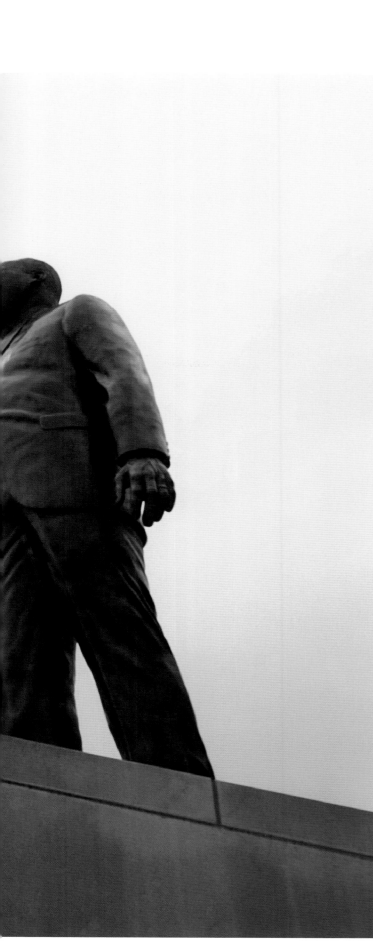

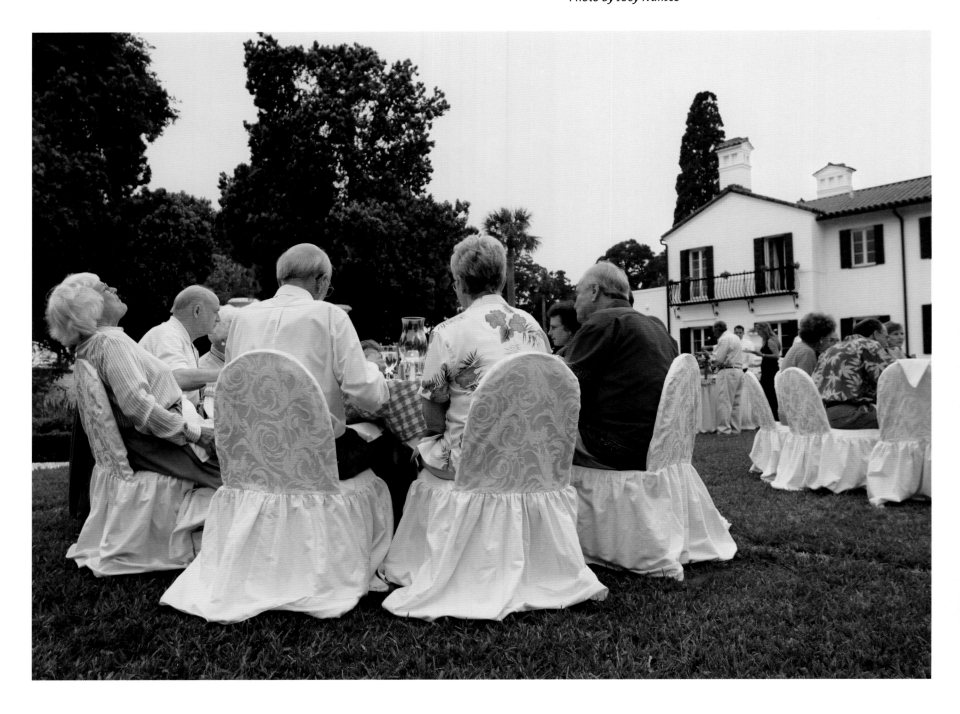

JEKYLL ISLAND

Crane Cottage serves as the backdrop for the rehearsal dinner prior to Jonathan Smylie and Amy Lyon's wedding. A favored wedding spot, the cottage was built in 1919 by plumbing magnate Richard Teller Crane, Jr. At the time, it was the most spacious and opulent cottage on Jekyll Island. Now, it's part of the Jekyll Island Club Hotel.

Photo by Flip Chalfant

PLAINS

Little did Candy Barfield know that when she rented her home behind this 13-foot peanut statue, her front lawn would become an international tourist attraction. A steady stream of visitors (60,000 pass through Plains annually) stop to have their picture taken in front of the monument inspired by Jimmy Carter's toothy grin. Plains (pop. 637) is the Nobel prizewinning former president's hometown.

Photo by Joey Ivansco

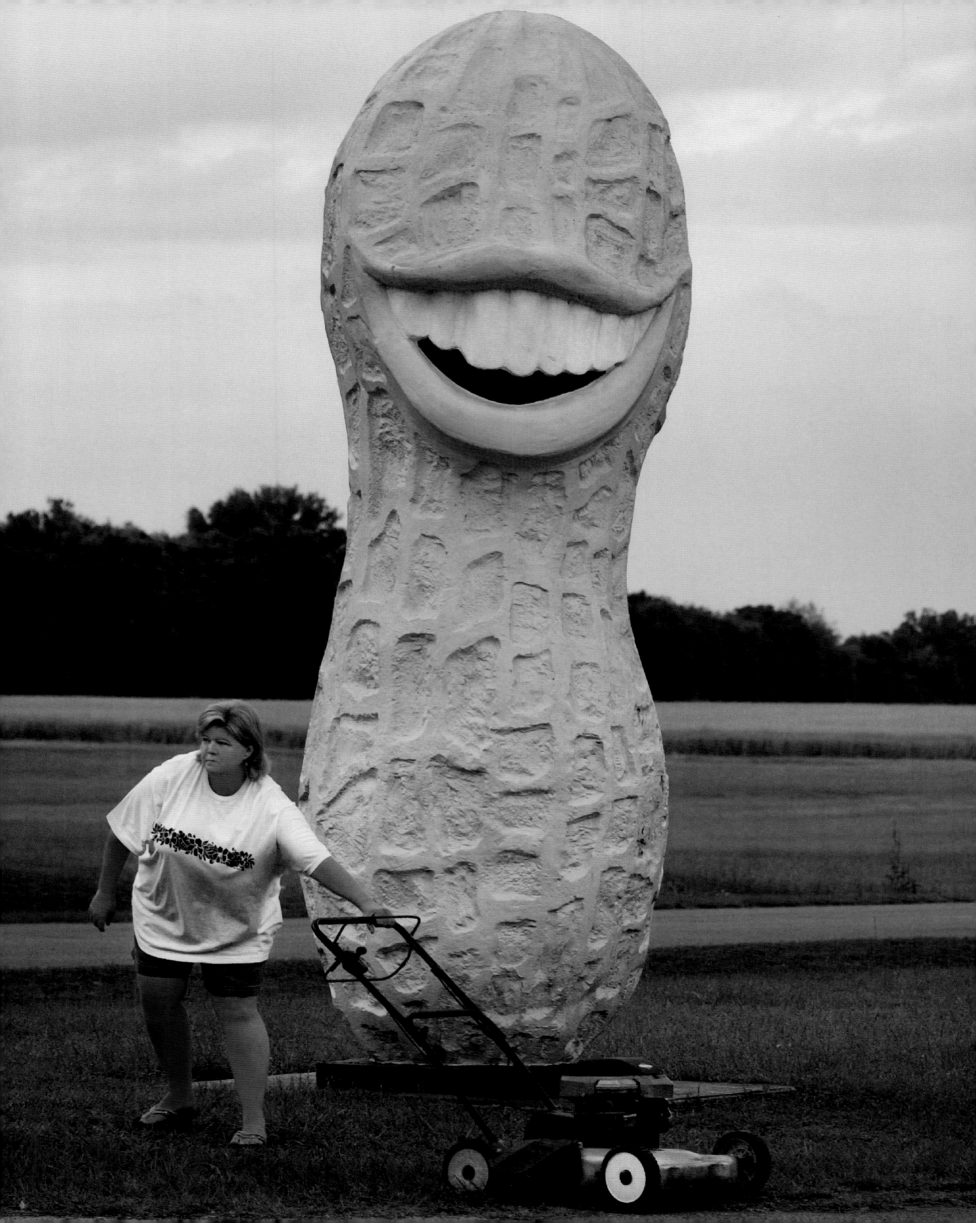

JEKYLL ISLAND
A day filled with memories and someone to share them with: Joel and Lucille Barnett return to the island they first visited as a young couple, 55 years ago.
Photo by Flip Chalfant

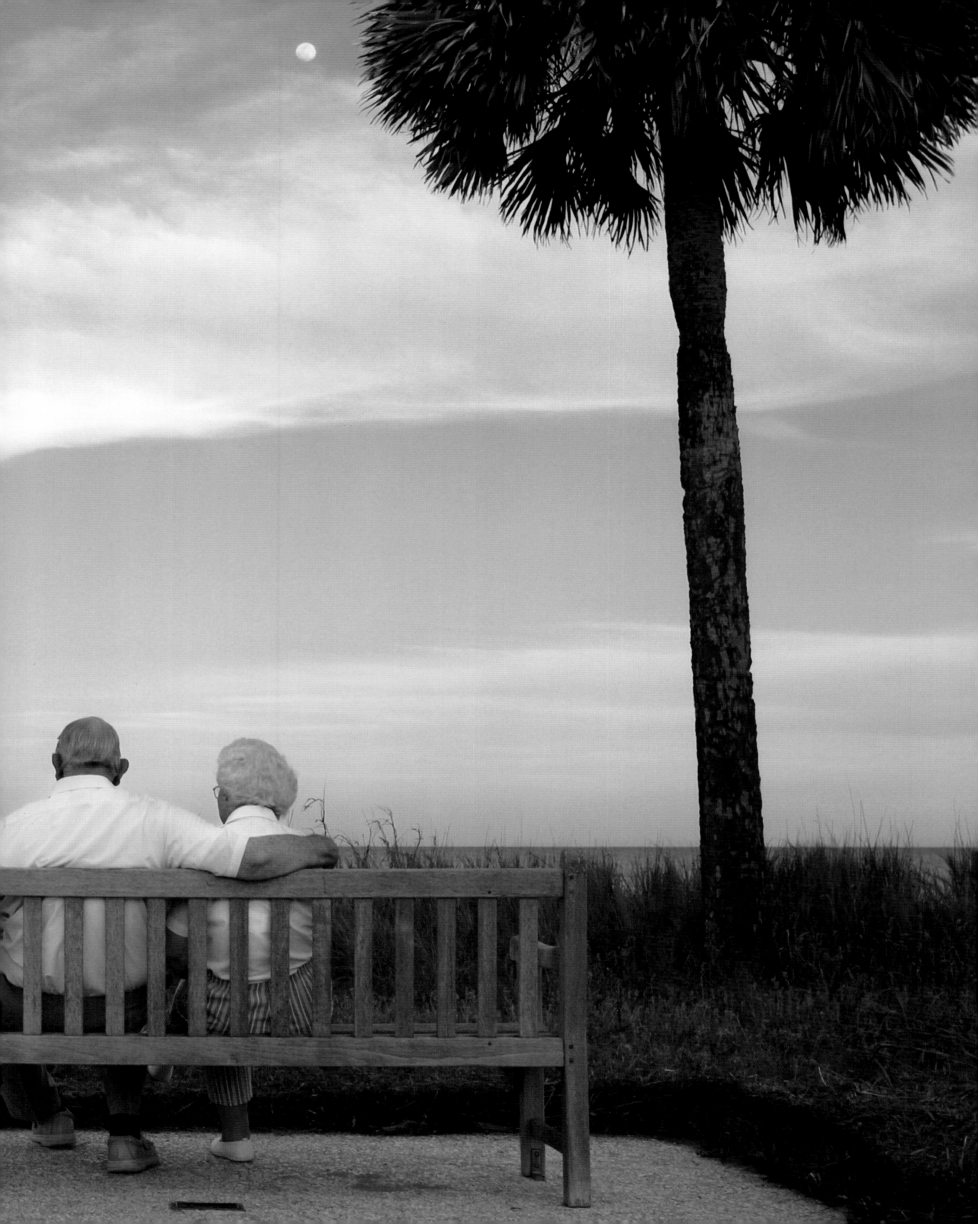

OKEFENOKEE NATIONAL WILDLIFE REFUGE
Racks of canoes line the boat basin at Stephen C. Foster State Park, named after the 19th-century songwriter who wrote the song "Old Folks at Home." Visitors can explore 25 miles of "boat trails" within the Okefenokee Swamp at the headwaters of the Suwanee River.
Photo by Rachel LaCour Niesen

CRESCENT

Snake Creek, a feeder stream for the coastal Sapelo River, coils around on itself like a serpent. This largely undeveloped wetland area of the Georgia coast, inland from the protective barrier islands, is a sanctuary for deer, otters, turtles, alligators, dolphins, and all sorts of birds: storks, herons, pelicans, cormorants, ospreys, and eagles.
Photo by Flip Chalfant

SYLVESTER

Ordered rows of peanut seeds stripe fields in Worth County, the self-proclaimed peanut capital of the world. The title is contested, however: Neighboring Early County produces more peanuts, but Worth County has more acres. The feud erupted beyond Georgia when the town of Dothan, Alabama, declared itself the capital in 1999.
Photo by Rich Addicks,
The Atlanta Journal-Constitution

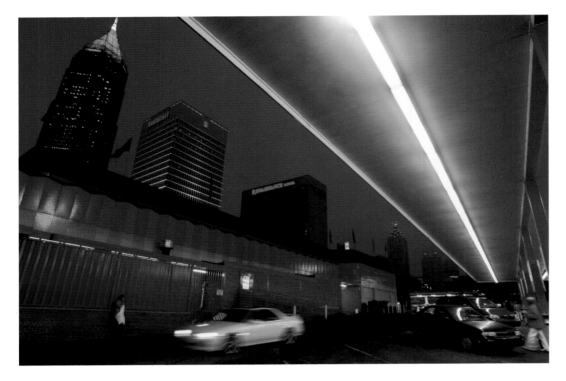

ATLANTA

Opened in 1928, the Varsity still has male carhops running the food to patrons outside. The cafe claims to be the world's largest drive-in, covering two blocks of downtown Atlanta and cooking 8,000 sizzling burgers a day. Customers who have chowed down on the signature chili dogs, onion fries, and fried pies include Elvis, Jimmy Carter, and Bill Clinton.
Photo by Jamie Squire

ATLANTA

Back in the 1950s, Zesto Drive-Ins were a regional chain. Today, they are all independently owned. The Zesto on Ponce de Leon Avenue still has chili dogs, double-deck cheeseburgers, and fountain indulgences like the Arctic Swirl and chocolate banana shakes.
Photo by Amanda Moulson

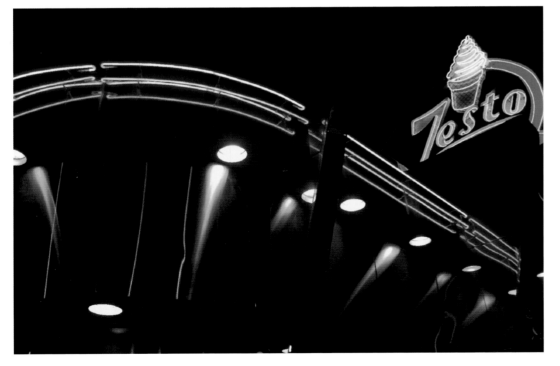

ATLANTA

Matrix Reloaded lights up at Starlight Six Drive-In. Built in 1949, Atlanta's last drive-in slid into disrepair until it was rescued 18 years ago by the current owners. According to manager Darrell Chafin, "We have a loyal following—about 80 percent repeat business."
Photo by Ben Gray

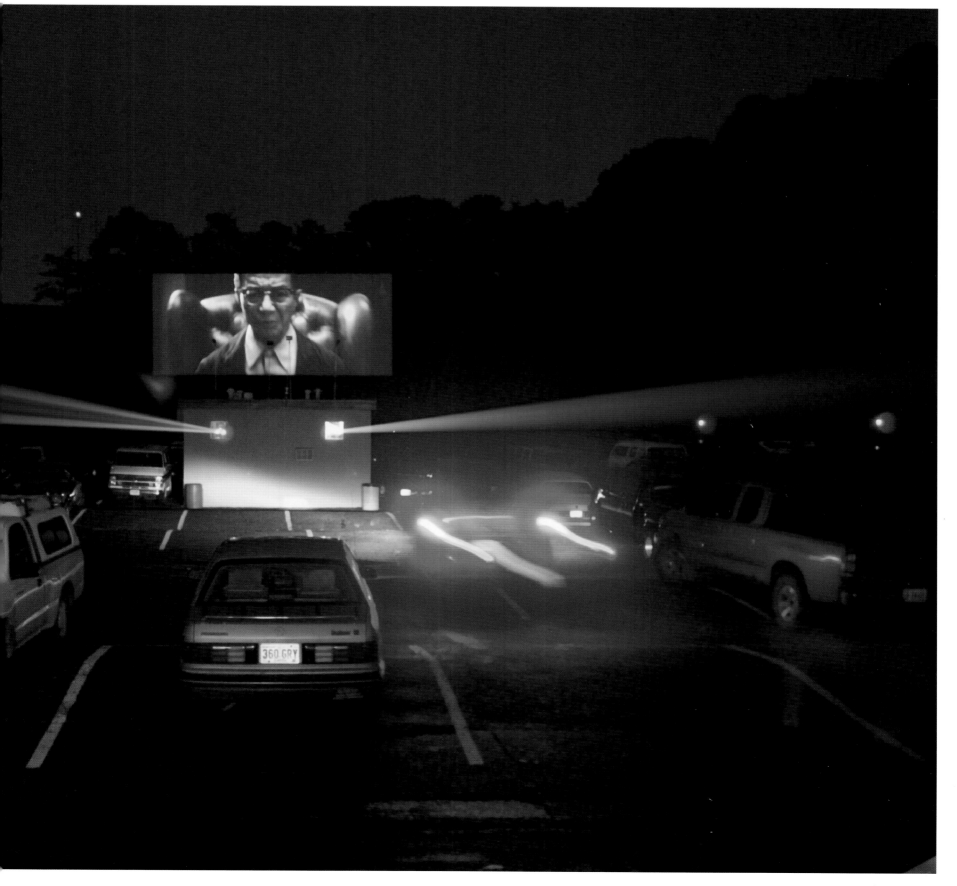

ATLANTA

The Egyptian Ballroom in Atlanta's Fox Theatre was the prom setting for 750 seniors from Woodstock High School. Senior Alison Ferrero and junior Luke Einon didn't really care what song the DJ was playing.

Photos by Andrew Niesen

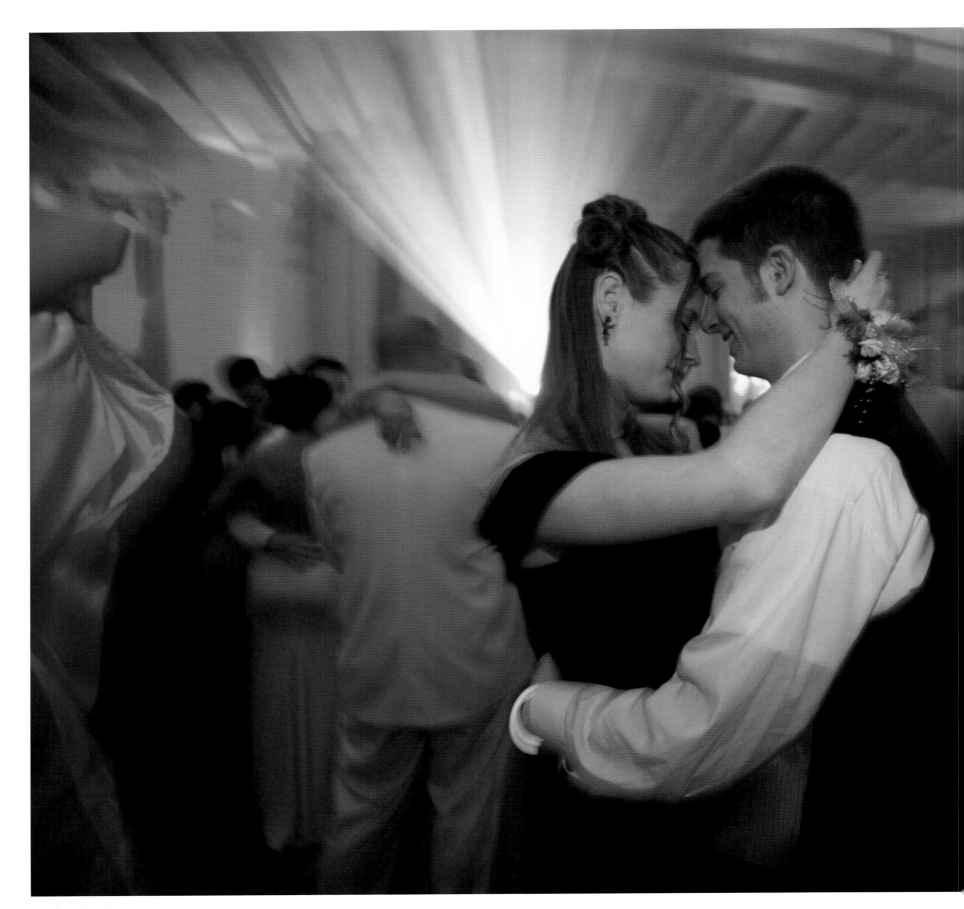

CANTON

Sophomore Jessica Rosie (left) was delighted to be Justin Correll's senior prom date and join Justin's pals, including senior Sarah Kline. "In Georgia, teens have a midnight curfew, so the prom ended at 11," says Jessica. "My mom was glad."

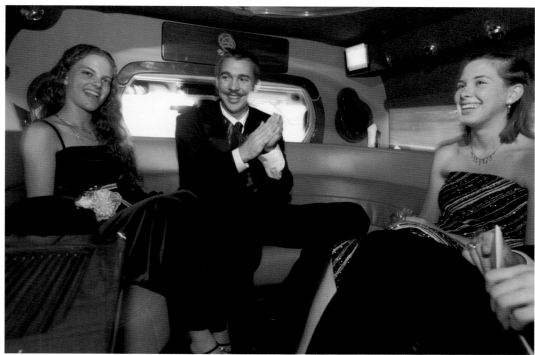

CRESCENT
Tinctures of sunrise stain the morning sky
and Crescent River marsh. Beyond the marsh
is Sapelo Island. Beyond that, the Atlantic.
Photo by Flip Chalfant

he week of May 12–18, 2003, more than 25,000 professional and amateur photographers spread out across the nation to shoot over a million digital photographs with the goal of capturing the essence of daily life in America.

The professional photographers were equipped with Adobe Photoshop and Adobe Album software, Olympus C-5050 digital cameras, and Lexar Media's high-speed compact flash cards.

The 1,000 professional contract photographers plus another 5,000 stringers and students sent their images via FTP (file transfer protocol) directly to the *America 24/7* website. Meanwhile, thousands of amateur photographers uploaded their images to Snapfish's servers.

At *America 24/7*'s Mission Control headquarters, located at CNET in San Francisco, dozens of picture editors from the nation's most prestigious publications culled the images down to 25,000 of the very best, using Photo Mechanic by Camera Bits. These photos were transferred into Webware's ActiveMedia Digital Asset Management (DAM) system, which served as a central image library and enabled the designers to track, search, distribute, and reformat the images for the creation of the 51 books, foreign language editions, web and magazine syndication, posters, and exhibitions.

Once in the DAM, images were optimized (and in some cases resampled to increase image resolution) using Adobe Photoshop. Adobe InDesign and Adobe InCopy were used to design and produce the 51 books, which were edited and reviewed in multiple locations around the world in the form of Adobe Acrobat PDFs. Epson Stylus printers were used for photo proofing and to produce large-format images for exhibitions. The companies providing support for the *America 24/7* project offer many of the essential components for anyone building a digital darkroom. We encourage you to

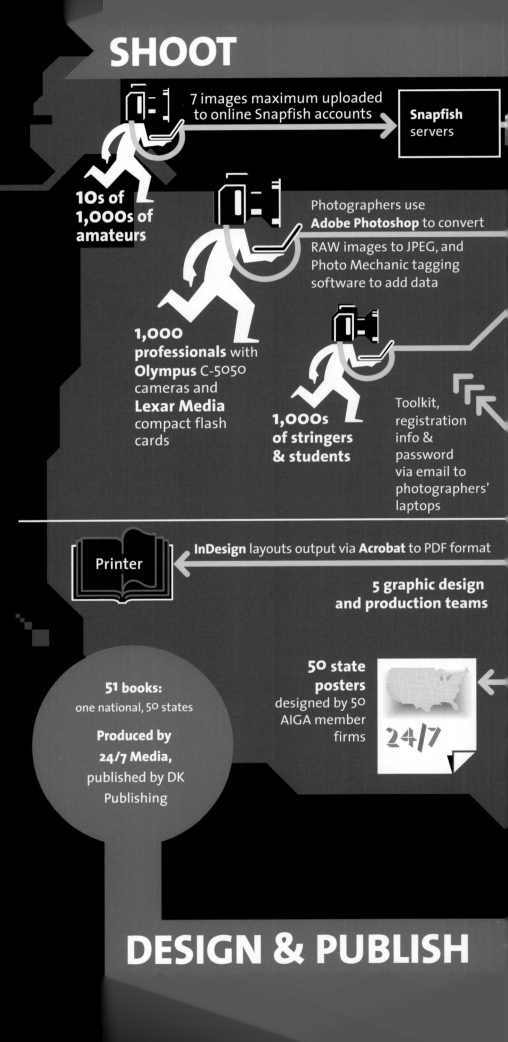

SHOOT

7 images maximum uploaded to online Snapfish accounts → **Snapfish** servers

10s of 1,000s of amateurs

Photographers use **Adobe Photoshop** to convert RAW images to JPEG, and Photo Mechanic tagging software to add data

1,000 professionals with **Olympus** C-5050 cameras and **Lexar Media** compact flash cards

1,000s of stringers & students

Toolkit, registration info & password via email to photographers' laptops

Printer ← **InDesign** layouts output via **Acrobat** to PDF format

5 graphic design and production teams

51 books: one national, 50 states
Produced by 24/7 Media, published by DK Publishing

50 state posters designed by 50 AIGA member firms

DESIGN & PUBLISH

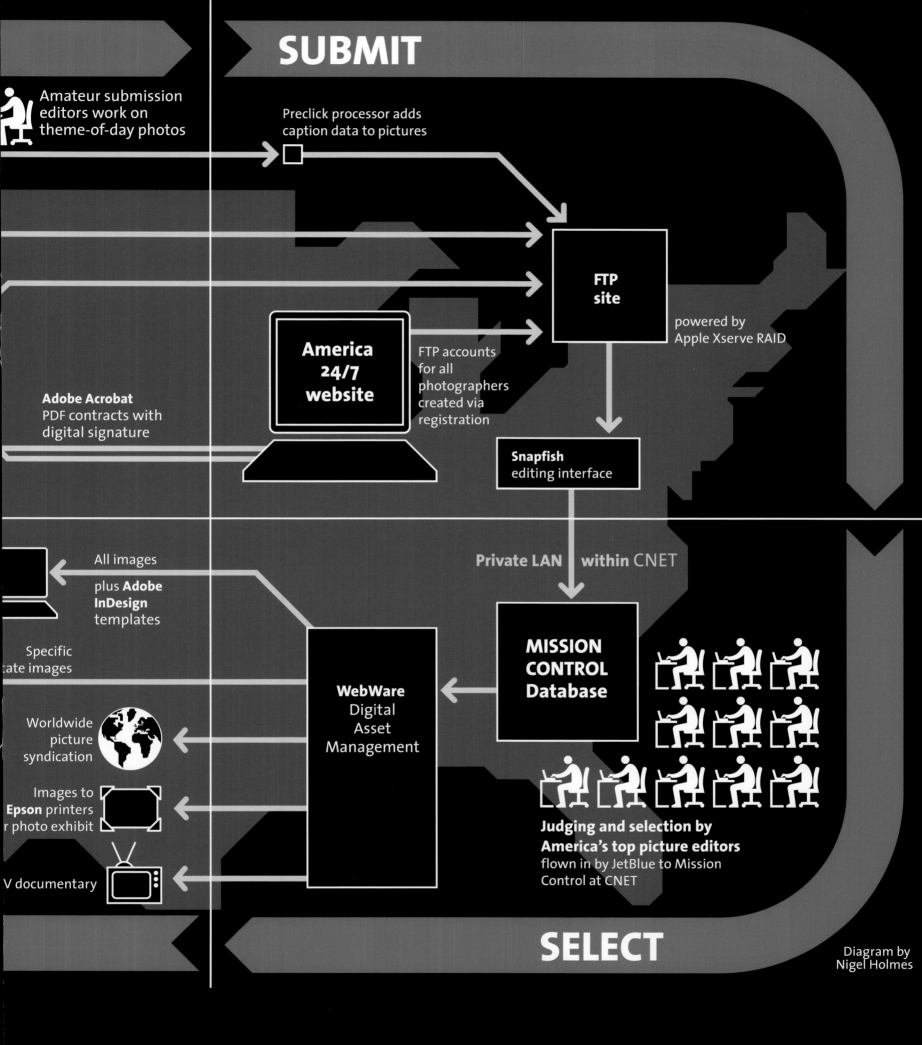

SUBMIT

Amateur submission editors work on theme-of-day photos

Preclick processor adds caption data to pictures

FTP site

powered by Apple Xserve RAID

America 24/7 website

FTP accounts for all photographers created via registration

Adobe Acrobat PDF contracts with digital signature

Snapfish editing interface

All images

plus **Adobe InDesign** templates

Private LAN within CNET

Specific ate images

WebWare Digital Asset Management

MISSION CONTROL Database

Worldwide picture syndication

Images to **Epson** printers r photo exhibit

Judging and selection by America's top picture editors flown in by JetBlue to Mission Control at CNET

V documentary

SELECT

Diagram by Nigel Holmes

Georgia 24/7

About Our Sponsors

America 24/7 gave digital photographers of all levels the opportunity to share their visions of what it means to live in the United States. This project was made possible by a digital photography revolution that is dramatically changing and improving picture-taking for professionals and amateurs alike. And an Adobe product, Photoshop®, has been at the center of this sea change.

Adobe's products reflect our customers' passion for the creative process, be it the photographer, graphic designer, layout artist, or printer. Adobe is the Publishing and Imaging Software Partner for *America 24/7* and products such as Adobe InDesign®, Photoshop, Acrobat®, and Illustrator® were used to produce this stunning book in a matter of weeks. We hope that our software has helped do justice to the mythic images, contributed by well-known photographers and the inspired hobbyist.

Adobe is proud to be a lead sponsor of *America 24/7*, a project that celebrates the vibrancy of the American spirit: the same spirit that helped found Adobe and inspires our employees and customers to deliver the very best.

Bruce Chizen
President and CEO
Adobe Systems Incorporated

Olympus, a global technology leader in designing precision healthcare solutions and innovative consumer electronics, is proud to be the official digital camera sponsor of *America 24/7*. The opportunity to introduce Americans from coast to coast to the thrill, excitement, and possibility of digital photography makes the vision behind this book a perfect fit for Olympus, a leader in digital cameras since 1996.

For most people, the essence of digital photography is best grasped through firsthand experience with the technology, which is precisely what *America 24/7* is about. We understand that direct experience is the pathway to inspiration, and welcome opportunities like this sponsorship to bring the power of the digital experience into the lives of people everywhere. To Olympus, *America 24/7* offers a platform to help realize a core mission: to deliver and make accessible the power of the digital experience to millions of American photographers, amateurs, and professionals alike.

The 1,000 professional photographers contracted to shoot on the America 24/7 project were all equipped with Olympus C-5050 digital cameras. Like all Olympus products, the C-5050 is offered by a company well known for designing, manufacturing, and servicing products used by professionals to perform their work, every day. Olympus is a customer-centric company committed to working one-to-one with a diverse group of professionals. From biomedical researchers who use our clinical microscopes, to doctors who perform life-saving procedures with our endoscopes, to professional photographers who use cameras in their daily work, Olympus is a trusted brand.

The digital imaging technology involved with *America 24/7* has enabled the soul of America to be visually conveyed, not just by professional observers, but by the American public who participated in this project—the very people who collectively breath life into this country's existence each day.

We are proud to be enabling so many photographers to capture the pictures on these pages that tell the story of who we are as a nation. From sea to shining sea, digital imagery allows us to connect to one another in ways we never dreamed possible.

At Olympus, our ideas have proliferated as rapidly as technology has evolved. We have channeled these visions into breakthrough products and solutions to meet the demands of our changing world-products like microscopes, endoscopes, and digital voice recorders, supported by the highly regarded training, educational, and consulting services we offer our customers.

Today, 83 years after we introduced our first microscope, we remain as young, as curious, and as committed as ever.

Lexar Media has grown from the digital photography revolution, which is why we are proud to have supplied the digital memory cards used in the America 24/7 project. Lexar Media's high-performance memory cards utilize our unique and patented controller coupled with high-speed flash memory from Samsung, the world's largest flash memory supplier. This powerful combination brings out the ultimate performance of any digital camera.

Photographers who demand the most from their equipment choose our products for their advanced features like write speeds up to 40X, Write Acceleration technology for enabled cameras, and Image Rescue, which recovers previously deleted or lost images. Leading camera manufacturers bundle Lexar Media digital memory cards with their cameras because they value its performance and reliability.

Lexar Media is at the forefront of digital photography as it transforms picture-taking worldwide, and we will continue to be a leader with new and innovative solutions for professionals and amateurs alike.

Snapfish, which developed the technology behind the *America 24/7* amateur photo event, is a leading online photo service, with more than 5 million members and 100 million photos posted online. Snapfish enables both film and digital camera owners to share, print, and store their most important photo memories, at prices that cannot be equaled. Digital camera users upload photos into a password-protected online album for free. Users can also order film-quality prints on professional photographic paper for as low as 25¢. Film camera users get a full set of prints, plus online sharing and storage, for just $2.99 per roll.

Founded in 1995, eBay created a powerful platform for the sale of goods and services by a passionate community of individuals and businesses. On any given day, there are millions of items across thousands of categories for sale on eBay. eBay enables trade on a local, national and international basis with customized sites in markets around the world.

Through an array of services, such as its payment solution provider PayPal, eBay is enabling global e-commerce for an ever-growing online community.

JetBlue Airways is proud to be *America 24/7's* preferred carrier, flying photographers, photo editors, and organizers across the United States.

Winner of Condé Nast Traveler's Readers' Choice Awards for Best Domestic Airline 2002, JetBlue provides friendly service and low fares for travelers in 22 cities in nine states across America.

On behalf of JetBlue's 5,000 crew members, we're excited to be involved in this remarkable project, and for the opportunity to serve American travelers each and every day, coast to coast, 24/7.

DIGITAL POND

Digital Pond has been a leading creator of large graphic displays for museums, corporations, trade shows, retail environments and fine art since 1992.

We were proud to bring together our creative, print and display capabilities to produce signage and displays for mission control, critical retouching for numerous key images for the book, and art galleries for the New York Public Library and Bryant Park.

The Pond's team and SplashPic® Online service enabled us to nimbly design, produce and install over 200 large graphic panels in two NYC locations within the truly "24/7" production schedule of less than ten days.

WebWare Corporation is pleased to be a major sponsor of the America 24/7 project. We take pride in being part of a groundbreaking adventure that is stretching the boundaries—and the imagination—in digital photography, digital asset management, publishing, news, and global events.

Our ActiveMedia Enterprise™ digital asset management software is the "nerve center" of *America 24/7*, the central repository for managing, sharing, and collaborating on the project's photographs. From photo editors and book publishers to 24/7's media relations and marketing personnel, ActiveMedia provides the application support that links all facets of the project team to the content worldwide.

WebWare helps Global 2000 firms securely manage, reuse, and distribute media assets locally or globally. Its suite of ActiveMedia software products provide powerful media services platforms for integrating rich media into content management systems marketing and communication portals; web publishing systems; and e-commerce portals.

Google

Google's mission is to organize the world's information and make it universally accessible and useful.

With our focus on plucking just the right answer from an ocean of data, we were naturally drawn to the America 24/7 project. The book you hold is a compendium of images of American life distilled from thousands of photographs and infinite possibilities. Are you looking for emotion? Narrative? Shadows? Light? It's all here, thanks to a multitude of photographers and writers creating links between you, the reader, and a sea of wonderful stories. We celebrate the connections that constitute the human experience and are pleased to help engender them. And we're pleased to have been a small part of this project, which captures the results of that interaction so vividly, so dynamically, and so dramatically.

Special thanks to additional contributors: FileMaker, Apple, Camera Bits, LaCie, Now Software, Preclick, Outpost Digital, Xerox, Microsoft, WoodWing Software, net-linx Publishing Solutions, and Radical Media. The Savoy Hotel, San Francisco; The Pan Pacific, San Francisco; Four Seasons Hotel, San Francisco; and The Queen Anne Hotel. Photography editing facilities were generously hosted by CNET Networks, Inc.

Participating Photographers

Coordinator: Rich Addicks, Staff Photographer, The Atlanta Journal-Constitution

Rich Addicks,
The Atlanta Journal-Constitution
Ria Allen
Tova R. Baruch
Jennifer Bowen Braswell
Rob Carr
Flip Chalfant
Tami Chappell
Carl Christie
Curtis Compton
James Davidson
Gene Driskell
Jonathan Ernst
Greg Foster
Karekin Goekjian
Philip Gould
Ben Gray
Chip Griffin
Phillip G. Harbin, Jr.

Virginia Holland
Joey Ivansco
Peter Loose
Stephen Morton, stephenmorton.com
Amanda Moulson
Pete Nicholls
Rachel LaCour Niesen
Andrew Niesen
Laura Noel
Dot Paul
Steven Schaefer
Jean Shifrin
Jeffrey Sowder
Jamie Squire
Mark Stayt
Sunny H. Sung,
The Atlanta Journal-Constitution
Matthew Williamson

Thumbnail Picture Credits

Credits for thumbnail photographs are listed by the page number and are in order from left to right.

20 Ben Gray
Phillip G. Harbin, Jr.
Ben Gray
Tova R. Baruch
Gene Driskell
Tova R. Baruch
Jennifer Bowen Braswell

21 Gene Driskell
Greg Foster
Gene Driskell
Phillip G. Harbin, Jr.
Andrew Niesen
Ben Gray
Matt Todd

22 Andrew Niesen
Curtis Compton
Rachel LaCour Niesen
Tami Chappell
Rachel LaCour Niesen
Rich Addicks,
The Atlanta Journal-Constitution
Flip Chalfant

23 Rachel LaCour Niesen
Rachel LaCour Niesen
Rachel LaCour Niesen
Flip Chalfant
Rachel LaCour Niesen
Rachel LaCour Niesen
Rachel LaCour Niesen

25 Greg Foster
Flip Chalfant
Ben Gray
Ben Gray
Phillip G. Harbin, Jr.
Laura Noel
Greg Foster

28 Tova R. Baruch
Tova R. Baruch
Tova R. Baruch
Karekin Goekjian
Joey Ivansco
Tova R. Baruch
Tova R. Baruch

29 Tova R. Baruch
Tova R. Baruch
Tova R. Baruch
Steven Schaefer

Tova R. Baruch
Tova R. Baruch
Tova R. Baruch

32 Chip Griffin
Andrew Niesen
Rich Addicks,
The Atlanta Journal-Constitution
Andrew Niesen
Andrew Niesen
Greg Foster
Rich Addicks,
The Atlanta Journal-Constitution

33 Jennifer Bowen Braswell
Andrew Niesen
Jennifer Bowen Braswell
Rich Addicks,
The Atlanta Journal-Constitution
Andrew Niesen
Greg Foster
Andrew Niesen

34 Charles B. Parker
Gene Driskell
Emily Bucy
Flip Chalfant
Gene Driskell
Joey Ivansco
Steven Schaefer

35 Gene Driskell
Gene Driskell
Pete Nicholls
Stephen Morton, stephenmorton.com
Pete Nicholls
Joey Ivansco
Tova R. Baruch

36 Philip Gould
Charles B. Parker
Philip Gould
Greg Foster
Joey Ivansco
Rob Carr
Greg Foster

37 Flip Chalfant
Joey Ivansco
Greg Foster
Rob Carr
Joey Ivansco
Stephen Morton, stephenmorton.com
Sunny H. Sung,
The Atlanta Journal-Constitution

38 Gene Driskell
Jennifer Bowen Braswell
Curtis Compton
Stanley Leary
Jennifer Bowen Braswell
Flip Chalfant
Jennifer Bowen Braswell

39 Joey Ivansco
Stanley Leary
Joey Ivansco
Jennifer Bowen Braswell
Joey Ivansco
Phillip G. Harbin, Jr.
Chip Griffin

48 Rich Addicks,
The Atlanta Journal-Constitution
Rich Addicks,
The Atlanta Journal-Constitution
Rich Addicks,
The Atlanta Journal-Constitution
Curtis Compton
Rich Addicks,
The Atlanta Journal-Constitution
Rich Addicks,
The Atlanta Journal-Constitution
Rich Addicks,
The Atlanta Journal-Constitution

49 Rich Addicks,
The Atlanta Journal-Constitution
Rich Addicks,
The Atlanta Journal-Constitution
Rich Addicks,
The Atlanta Journal-Constitution
Rich Addicks,
The Atlanta Journal-Constitution
Rich Addicks,
The Atlanta Journal-Constitution
Rich Addicks,
The Atlanta Journal-Constitution
Rich Addicks,
The Atlanta Journal-Constitution

50 Charles B. Parker
Flip Chalfant
Greg Foster
Joey Ivansco
Karekin Goekjian
Flip Chalfant
Karekin Goekjian

51 Jennifer Bowen Braswell
Joey Ivansco
Greg Foster
Philip Gould
Flip Chalfant
Karekin Goekjian
Rob Carr

52 Karekin Goekjian
Jonathan Ernst
Leita Cowart
Jonathan Ernst
Jonathan Ernst
Leita Cowart
Curtis Compton

53 Jonathan Ernst
Jonathan Ernst
Leita Cowart
Jonathan Ernst
Jonathan Ernst
Karekin Goekjian
Gene Driskell

54 Jonathan Ernst
Rich Addicks,
The Atlanta Journal-Constitution
Chris Livingston
Rich Addicks,
The Atlanta Journal-Constitution
Gene Driskell
Greg Foster
Chris Livingston

55 Ben Gray
Karekin Goekjian
Jonathan Ernst
Gene Driskell
Rich Addicks,
The Atlanta Journal-Constitution
Karekin Goekjian
Gene Driskell

58 Flip Chalfant
Flip Chalfant
Flip Chalfant
Flip Chalfant
Stephen Morton, stephenmorton.com
Flip Chalfant
Flip Chalfant

59 Flip Chalfant
Flip Chalfant
Flip Chalfant
Flip Chalfant
Flip Chalfant
Flip Chalfant
Flip Chalfant

60 Gene Driskell
Gene Driskell
Gene Driskell
Sunny H. Sung,
The Atlanta Journal-Constitution
Ben Gray
Ben Gray
Chris Livingston

61 Ben Gray
Steven Schaefer
Ben Gray
Steven Schaefer
Gene Driskell
Gene Driskell
Ben Gray

62 Stanley Leary
Jamie Squire
Jamie Squire
Stanley Leary
Jamie Squire
Jamie Squire
Jamie Squire

63 Stanley Leary
Jamie Squire
Jamie Squire
Tova R. Baruch
Jamie Squire
Jean Shifrin
Jamie Squire

64 Rob Carr
Tami Chappell
Philip Gould
Jamie Squire
Sunny H. Sung,
The Atlanta Journal-Constitution
Jonathan Ernst
Rob Carr

65 Tami Chappell
Tami Chappell
Renee Lawrence
Sunny H. Sung,
The Atlanta Journal-Constitution
Jonathan Ernst
Tova R. Baruch
Tami Chappell

68 Rich Addicks,
The Atlanta Journal-Constitution
Joey Ivansco
Emily Bucy
Jonathan Ernst
Rich Addicks,
The Atlanta Journal-Constitution
Curtis Compton
Laura Noel

69 Tami Chappell
Joey Ivansco
Pete Nicholls
Rich Addicks,
The Atlanta Journal-Constitution
Jamie Squire
Phillip G. Harbin, Jr.
Curtis Compton

70 Greg Foster
Flip Chalfant
Steven Schaefer
Flip Chalfant
Greg Foster
Flip Chalfant
Jamie Squire

71 Karekin Goekjian
Jamie Squire
Greg Foster
Greg Foster
Karekin Goekjian
Karekin Goekjian
Phillip G. Harbin, Jr.

72 Andrew Niesen
Sunny H. Sung,
The Atlanta Journal-Constitution
Andrew Niesen
Flip Chalfant
Stephen Morton, stephenmorton.com
Pete Nicholls
Stephen Morton, stephenmorton.com

73 Gene Driskell
Rob Carr
Andrew Niesen
Stephen Morton, stephenmorton.com
Tami Chappell
Tami Chappell
Sunny H. Sung,
The Atlanta Journal-Constitution

76 Ben Gray
Ben Gray
Stephen Morton, stephenmorton.com
Ben Gray
Karekin Goekjian
Flip Chalfant
Ben Gray

77 Flip Chalfant
Ben Gray
Phillip G. Harbin, Jr.
Ben Gray
Phillip G. Harbin, Jr.
Gene Driskell
Steven Schaefer

80 Gene Driskell
Curtis Compton
Flip Chalfant
Sunny H. Sung,
The Atlanta Journal-Constitution
Flip Chalfant
Gene Driskell
Gene Driskell

81 Gene Driskell
Flip Chalfant
Curtis Compton
Sunny H. Sung,
The Atlanta Journal-Constitution
Flip Chalfant
Sunny H. Sung,
The Atlanta Journal-Constitution
Curtis Compton

82 Jean Shifrin
Chris Livingston
Rich Addicks,
The Atlanta Journal-Constitution
Jean Shifrin
Chip Griffin
Laura Noel
Jean Shifrin

83 Jean Shifrin
Jean Shifrin
Laura Noel
Jean Shifrin
Chris Livingston
Jean Shifrin
Jean Shifrin

85 Steven Schaefer
Chip Griffin
Chip Griffin
Steven Schaefer
Chip Griffin
Jamie Squire
Chip Griffin

86 Laura Noel
Rich Addicks,
The Atlanta Journal-Constitution
Laura Noel
Rich Addicks,
The Atlanta Journal-Constitution
Laura Noel
Rob Carr
Gene Driskell

87 Jean Shifrin
Steven Schaefer
Steven Schaefer
Rob Carr
Rob Carr
Laura Noel
Tami Chappell

88 Greg Foster
Ben Gray
Jamie Squire
Gene Driskell
Flip Chalfant
Jonathan Ernst
Jean Shifrin

89 Jonathan Ernst
Flip Chalfant
Jamie Squire
Rob Carr
Jamie Squire
Stephen Morton, stephenmorton.com
Jamie Squire

94 Ben Gray
Curtis Compton
Ben Gray
Curtis Compton
Ben Gray
Ben Gray
Curtis Compton

95 Curtis Compton
Ben Gray
Curtis Compton
Rich Addicks,
The Atlanta Journal-Constitution
Curtis Compton
Curtis Compton
Curtis Compton

96 Steven Schaefer
Charles B. Parker
Steven Schaefer
Charles B. Parker
Karekin Goekjian
Steven Schaefer
Karekin Goekjian

97 Steven Schaefer
Steven Schaefer
Rich Addicks,
The Atlanta Journal-Constitution
Steven Schaefer
Tami Chappell
Sunny H. Sung,
The Atlanta Journal-Constitution
Tova R. Baruch

98 Sunny H. Sung,
The Atlanta Journal-Constitution
Sunny H. Sung,
The Atlanta Journal-Constitution
Tami Chappell
Sunny H. Sung,
The Atlanta Journal-Constitution
Tami Chappell
Sunny H. Sung,
The Atlanta Journal-Constitution
Sunny H. Sung,
The Atlanta Journal-Constitution

101 Joey Ivansco
Joey Ivansco
Joey Ivansco
Joey Ivansco
Steven Schaefer
Phillip G. Harbin, Jr.
Joey Ivansco

104 Andrew Niesen
Tami Chappell
Stephen Morton, stephenmorton.com
Andrew Niesen
Curtis Compton
Jonathan Ernst
Stephen Morton, stephenmorton.com

105 Flip Chalfant
Stephen Morton, stephenmorton.com
Gene Driskell
Rachel LaCour Niesen
Stephen Morton, stephenmorton.com
Tami Chappell
Stephen Morton, stephenmorton.com

106 Steven Schaefer
Steven Schaefer
Flip Chalfant
Joey Ivansco
Chris Livingston
Curtis Compton
Curtis Compton

107 Tami Chappell
Joey Ivansco
Stephen Morton, stephenmorton.com
Stephen Morton, stephenmorton.com
Steven Schaefer
Chris Livingston
Jean Shifrin

110 Rich Addicks,
The Atlanta Journal-Constitution
Phillip G. Harbin, Jr.
Joey Ivansco
Jean Shifrin
Laura Noel
Megan Edge,
Savannah College of Art and Design
Steven Schaefer

111 Joey Ivansco
Rich Addicks,
The Atlanta Journal-Constitution
Gene Driskell
Phillip G. Harbin, Jr.
Joey Ivansco
Steven Schaefer
Gene Driskell

114 Jean Shifrin
Jean Shifrin
Jean Shifrin
Gene Driskell
Laura Noel
Karekin Goekjian

115 Karekin Goekjian
Gene Driskell
Laura Noel
Jean Shifrin
Karekin Goekjian
Laura Noel
Gene Driskell

116 Greg Foster
Sunny H. Sung,
The Atlanta Journal-Constitution
Laura Noel
Steven Schaefer
Gene Driskell
Laura Noel
Gene Driskell

117 Steven Schaefer
Sunny H. Sung,
The Atlanta Journal-Constitution
Gene Driskell
Steven Schaefer
Greg Foster
Steven Schaefer
Steven Schaefer

119 Laura Noel
Laura Noel
Laura Noel
Laura Noel
Laura Noel
Tami Chappell
Laura Noel

120 Gene Driskell
Flip Chalfant
Greg Foster
Gene Driskell
Phillip G. Harbin, Jr.
Emily Bucy
Joey Ivansco

121 Joey Ivansco
Stephen Morton, stephenmorton.com
Gene Driskell
Joey Ivansco
Rob Carr
Joey Ivansco
Rob Carr

122 Jamie Squire
Amanda Moulson
Karekin Goekjian
Flip Chalfant
Greg Foster
Jamie Squire
Flip Chalfant

123 Jamie Squire
Ben Gray
Jamie Squire
Jamie Squire
Flip Chalfant
Flip Chalfant
Karekin Goekjian

124 Joey Ivansco
Charles B. Parker
Joey Ivansco
Joey Ivansco
Phillip G. Harbin, Jr.
Rachel LaCour Niesen
Phillip G. Harbin, Jr.

125 Rachel LaCour Niesen
Rob Carr
Rachel LaCour Niesen
Joey Ivansco
Gene Driskell
Rachel LaCour Niesen
Tami Chappell

126 Joey Ivansco
Flip Chalfant
Rob Carr
Gene Driskell
Joey Ivansco
Flip Chalfant
Charles B. Parker

130 Andrew Niesen
Rachel LaCour Niesen
Flip Chalfant
Flip Chalfant
Rachel LaCour Niesen
Flip Chalfant
Rachel LaCour Niesen

131 Rachel LaCour Niesen
Flip Chalfant
Stephen Morton, stephenmorton.com
Rachel LaCour Niesen
Rich Addicks,
The Atlanta Journal-Constitution
Rachel LaCour Niesen
Rachel LaCour Niesen

132 Greg Foster
Jamie Squire
Amanda Moulson
Greg Foster
Amanda Moulson
Flip Chalfant
Joey Ivansco

133 Flip Chalfant
Gene Driskell
Joey Ivansco
Gene Driskell
Ben Gray
Gene Driskell
Philip Gould

134 Andrew Niesen
Rich Addicks,
The Atlanta Journal-Constitution
Andrew Niesen
Flip Chalfant
Andrew Niesen
Andrew Niesen
Andrew Niesen

135 Jean Shifrin
Andrew Niesen
Phillip G. Harbin, Jr.
Andrew Niesen
Andrew Niesen
Stephen Morton, stephenmorton.com
Andrew Niesen

Staff

The *America 24/7* series was imagined years ago by our friend Oscar Dystel, a publishing legend whose vision and enthusiasm have been a source of great inspiration.

We also wish to express our gratitude to our truly visionary publisher, DK.

Rick Smolan, Project Director
David Elliot Cohen, Project Director

Administrative
Katya Able, Operations Director
Gina Privitere, Communications Director
Chuck Gathard, Technology Director
Kim Shannon, Photographer Relations Director
Erin O'Connor, Photographer Relations Intern
Leslie Hunter, Partnership Director
Annie Polk, Publicity Manager
John McAlester, Website Manager
Alex Notides, Office Manager
C. Thomas Hardin, State Photography Coordinator

Design
Brad Zucroff, Creative Director
Karen Mullarkey, Photography Director
Judy Zimola, Production Manager
David Simoni, Production Designer
Mary Dias, Production Designer
Heidi Madison, Associate Picture Editor
Don McCartney, Production Designer
Diane Dempsey Murray, Production Designer
Jan Rogers, Associate Picture Editor
Bill Shore, Production Designer and Image Artist
Larry Nighswander, Senior Picture Editor
Bill Marr, Sarah Leen, Senior Picture Editors
Peter Truskier, Workflow Consultant
Jim Birkenseer, Workflow Consultant

Editorial
Maggie Canon, Managing Editor
Curt Sanburn, Senior Editor
Teresa L. Trego, Production Editor
Lea Aschkenas, Writer
Olivia Boler, Writer
Korey Capozza, Writer
Beverly Hanly, Writer
Bridgett Novak, Writer
Alison Owings, Writer
Fred Raker, Writer
Joe Wolff, Writer
Elise O'Keefe, Copy Chief
Will Hector, Copy Editor
Daisy Hernández, Copy Editor
Jennifer Wolfe, Copy Editor

Infographic Design
Nigel Holmes

Literary Agent
Carol Mann, The Carol Mann Agency

Legal Counsel
Barry Reder, Coblentz, Patch, Duffy & Bass, LLP
Phil Feldman, Coblentz, Patch, Duffy & Bass, LLP
Gabe Perle, Ohlandt, Greeley, Ruggiero & Perle, LLP
Jon Hart, Dow, Lohnes & Albertson, PLLC
Mike Hays, Dow, Lohnes & Albertson, PLLC
Stephen Pollen, Warshaw Burstein, Cohen, Schlesinger & Kuh, LLP
Rick Pappas

Accounting and Finance
Rita Dulebohn, Accountant
Robert Powers, Calegari, Morris & Co. Accountants
Eugene Blumberg, Blumberg & Associates
Arthur Langhaus, KLS Professional Advisors Group, Inc.

Picture Editors
J. David Ake, Associated Press
Caren Alpert, formerly *Health* magazine
Simon Barnett, *Newsweek*
Caroline Couig, *San Jose Mercury News*
Mike Davis, formerly *National Geographic*
Michel duCille, *Washington Post*
Deborah Dragon, *Rolling Stone*
Victor Fisher, formerly Associated Press
Frank Folwell, *USA Today*
MaryAnne Golon, *Time*
Liz Grady, formerly *National Geographic*
Randall Greenwell, *San Francisco Chronicle*
C. Thomas Hardin, formerly *Louisville Courier-Journal*
Kathleen Hennessy, *San Francisco Chronicle*
Scot Jahn, *U.S. News & World Report*
Steve Jessmore, *Flint Journal*
John Kaplan, University of Florida
Kim Komenich, *San Francisco Chronicle*
Eliane Laffont, *Hachette Filipacchi Media*
Jean-Pierre Laffont, *Hachette Filipacchi Media*
Andrew Locke, MSNBC
Jose Lopez, *The New York Times*
Maria Mann, formerly AFP
Bill Marr, formerly *National Geographic*
Michele McNally, *Fortune*
James Merithew, *San Francisco Chronicle*
Eric Meskauskas, *New York Daily News*
Maddy Miller, *People* magazine
Michelle Molloy, *Newsweek*
Dolores Morrison, *New York Daily News*
Karen Mullarkey, formerly *Newsweek, Rolling Stone, Sports Illustrated*
Larry Nighswander, Ohio University School of Visual Communication
Jim Preston, *Baltimore Sun*
Sarah Rozen, formerly *Entertainment Weekly*
Mike Smith, *The New York Times*
Neal Ulevich, formerly Associated Press

Website and Digital Systems
Jeff Burchell, Applications Engineer

Television Documentary
Sandy Smolan, Producer/Director
Rick King, Producer/Director
Bill Medsker, Producer

Video News Release
Mike Cerre, Producer/Director

Digital Pond
Peter Hogg
Kris Knight
Roger Graham
Philip Bond
Frank De Pace
Lisa Li

Senior Advisors
Jennifer Erwitt, Strategic Advisor
Tom Walker, Creative Advisor
Megan Smith, Technology Advisor
Jon Kamen, Media and Partnership Advisor
Mark Greenberg, Partnership Advisor
Patti Richards, Publicity Advisor
Cotton Coulson, Mission Control Advisor

Executive Advisors
Sonia Land
George Craig
Carole Bidnick

Advisors
Chris Anderson
Samir Arora
Russell Brown
Craig Cline
Gayle Cline
Harlan Felt
George Fisher
Phillip Moffitt
Clement Mok
Laureen Seeger
Richard Saul Wurman

DK Publishing
Bill Barry
Joanna Bull
Therese Burke
Sarah Coltman
Christopher Davis
Todd Fries
Dick Heffernan
Jay Henry
Stuart Jackman
Stephanie Jackson
Chuck Lang
Sharon Lucas
Cathy Melnicki
Nicola Munro
Eunice Paterson
Andrew Welham

Colourscan
Jimmy Tsao
Eddie Chia
Richard Law
Josephine Yam
Paul Koh
Chee Cheng Yeong
Dan Kang

Chief Morale Officer
Goose, the dog